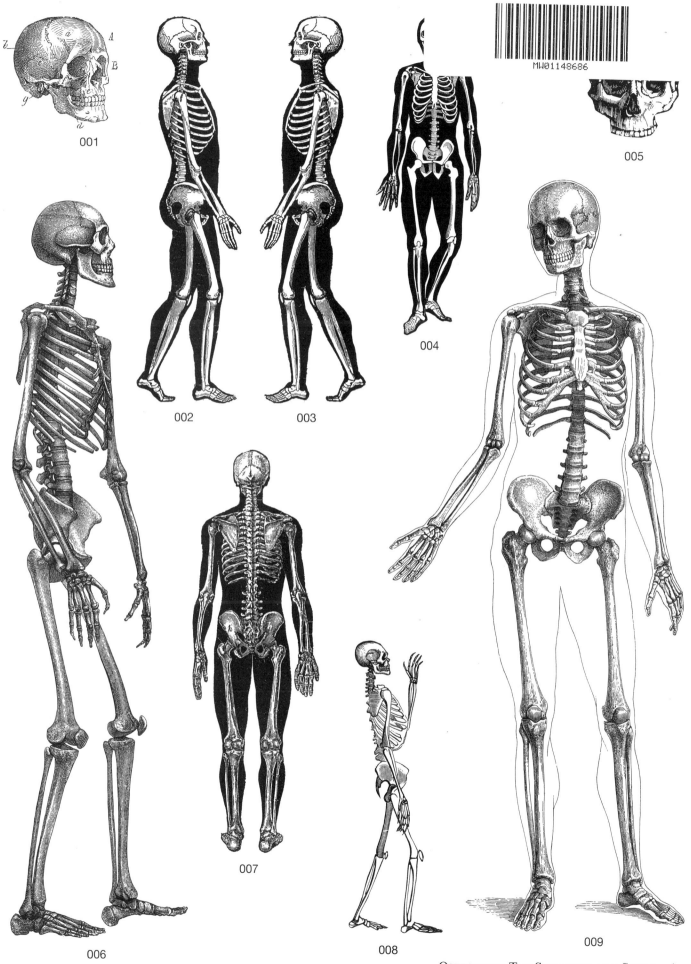

001

002 003

004

005

006

007

008

009

MW01148686

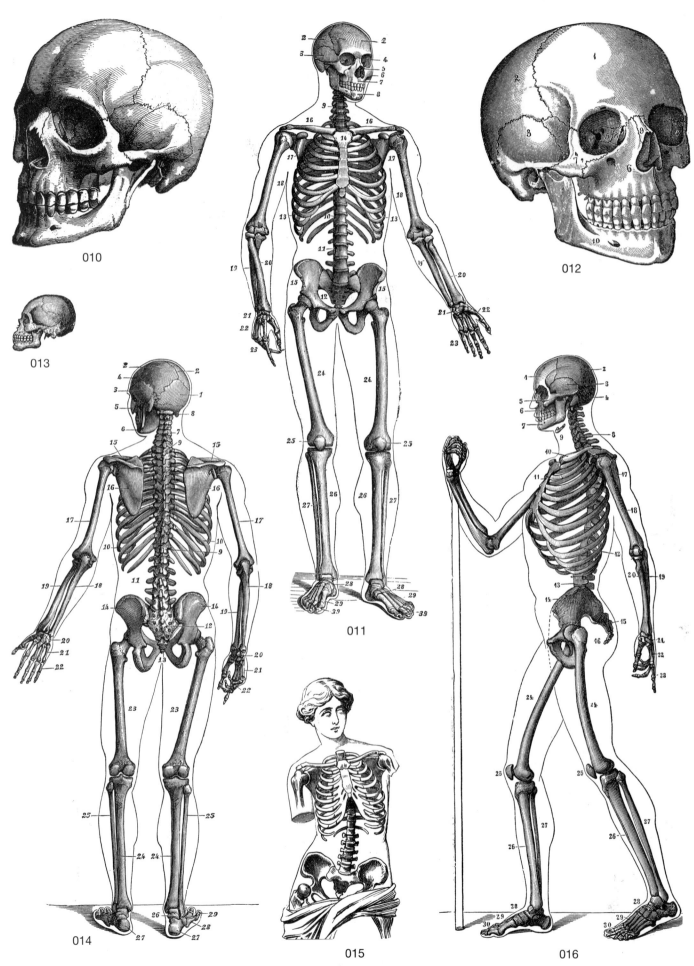

010

013

011

014

015

012

016

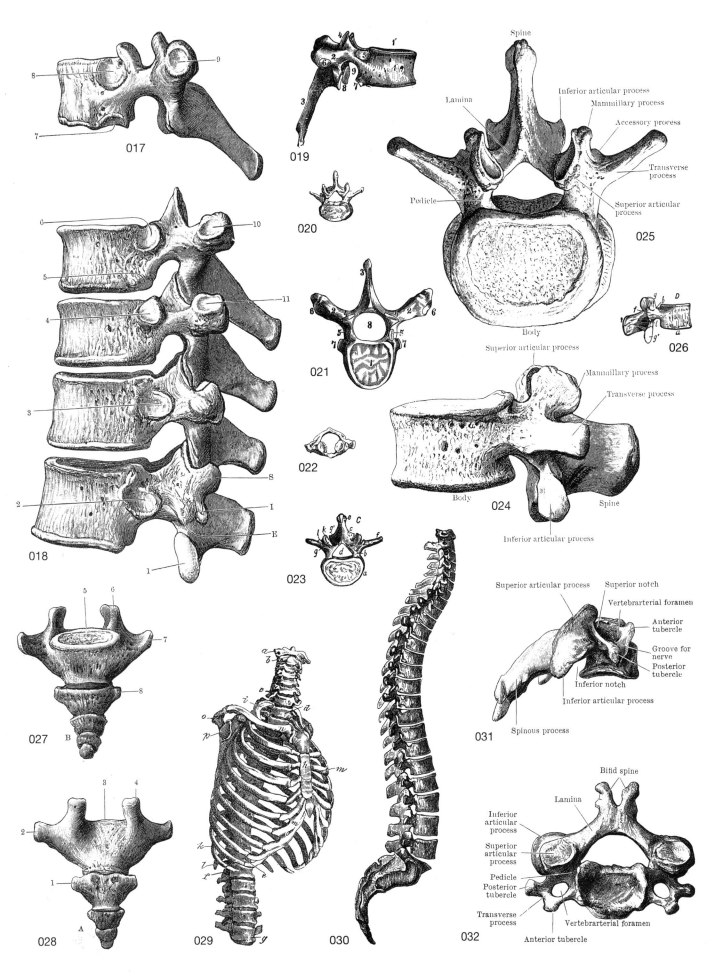

017

019

020

021

022

023

024

025

026

027

028

029

030

031

032

018

Figure 025 labels:
Spine
Inferior articular process
Mammillary process
Accessory process
Transverse process
Lamina
Pedicle
Superior articular process
Body

Figure 024 labels:
Superior articular process
Mammillary process
Transverse process
Body
Inferior articular process
Spine

Figure 031 labels:
Superior articular process
Superior notch
Vertebrarterial foramen
Anterior tubercle
Groove for nerve
Posterior tubercle
Inferior notch
Inferior articular process
Spinous process

Figure 032 labels:
Bifid spine
Lamina
Inferior articular process
Superior articular process
Pedicle
Posterior tubercle
Transverse process
Vertebrarterial foramen
Anterior tubercle

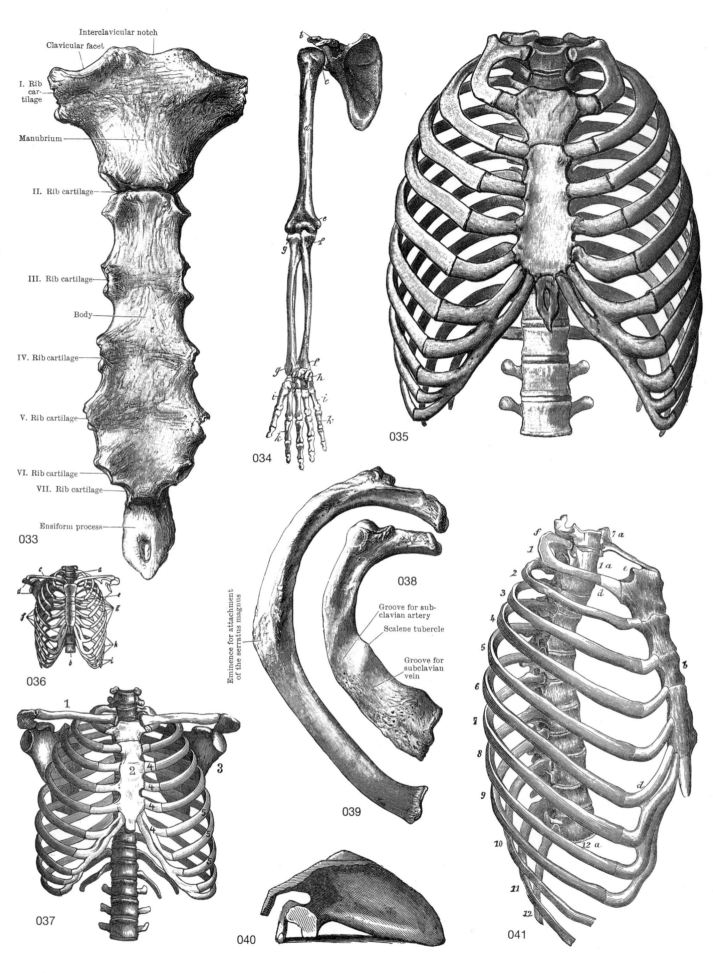

Interclavicular notch

Clavicular facet

I. Rib
cartilage

Manubrium

II. Rib cartilage

III. Rib cartilage

Body

IV. Rib cartilage

V. Rib cartilage

VI. Rib cartilage

VII. Rib cartilage

Ensiform process

033

034

035

036

037

038

Eminence for attachment
of the serratus magnus

039

Groove for sub-
clavian artery

Scalene tubercle

Groove for
subclavian
vein

040

041

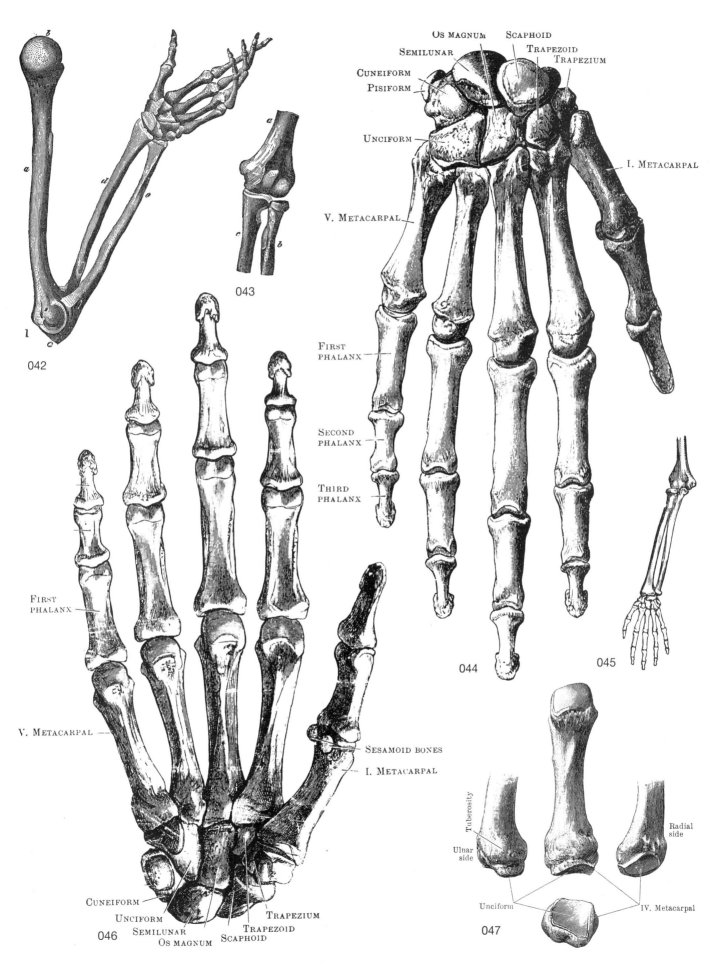

042

043

044

CUNEIFORM
PISIFORM

SEMILUNAR

OS MAGNUM SCAPHOID

TRAPEZOID
TRAPEZIUM

UNCIFORM

I. METACARPAL

V. METACARPAL

FIRST
PHALANX

SECOND
PHALANX

THIRD
PHALANX

045

FIRST
PHALANX

V. METACARPAL

SESAMOID BONES

I. METACARPAL

CUNEIFORM
UNCIFORM
SEMILUNAR
OS MAGNUM
TRAPEZIUM
TRAPEZOID
SCAPHOID

046

047

Tuberosity

Ulnar
side

Radial
side

Unciform

IV. Metacarpal

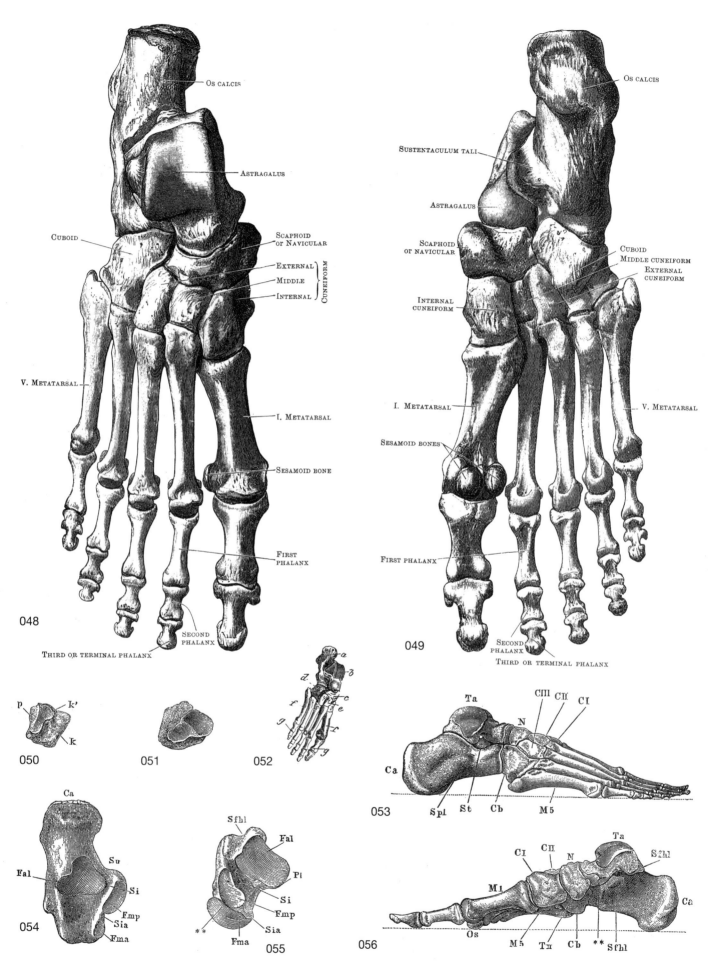

048

OS CALCIS

ASTRAGALUS

CUBOID

SCAPHOID
or NAVICULAR

EXTERNAL
MIDDLE
INTERNAL

CUNEIFORM

V. METATARSAL

I. METATARSAL

SESAMOID BONE

FIRST
PHALANX

SECOND
PHALANX

THIRD OR TERMINAL PHALANX

049

OS CALCIS

SUSTENTACULUM TALI

ASTRAGALUS

SCAPHOID
or NAVICULAR

CUBOID
MIDDLE CUNEIFORM
EXTERNAL
CUNEIFORM

INTERNAL
CUNEIFORM

I. METATARSAL

V. METATARSAL

SESAMOID BONES

FIRST PHALANX

SECOND
PHALANX

THIRD OR TERMINAL PHALANX

050

p k'
 k

051

052

a
b
d
c
e
f
e
f
g
g

053

Ta
CIII CII CI
N
Ca
Spl St Cb M 5

054

Ca
Su
Fal
Si
Fmp
Sia
Fma

055

Sfhl
Fal
Pl
Si
Fmp
** Sia
Fma

056

CI CII
N
Ta
M 1
Sfhl
Ca
Os
M 5 TII Cb ** Sfhl

6 OSTEOLOGY: THE LOWER EXTREMITIES

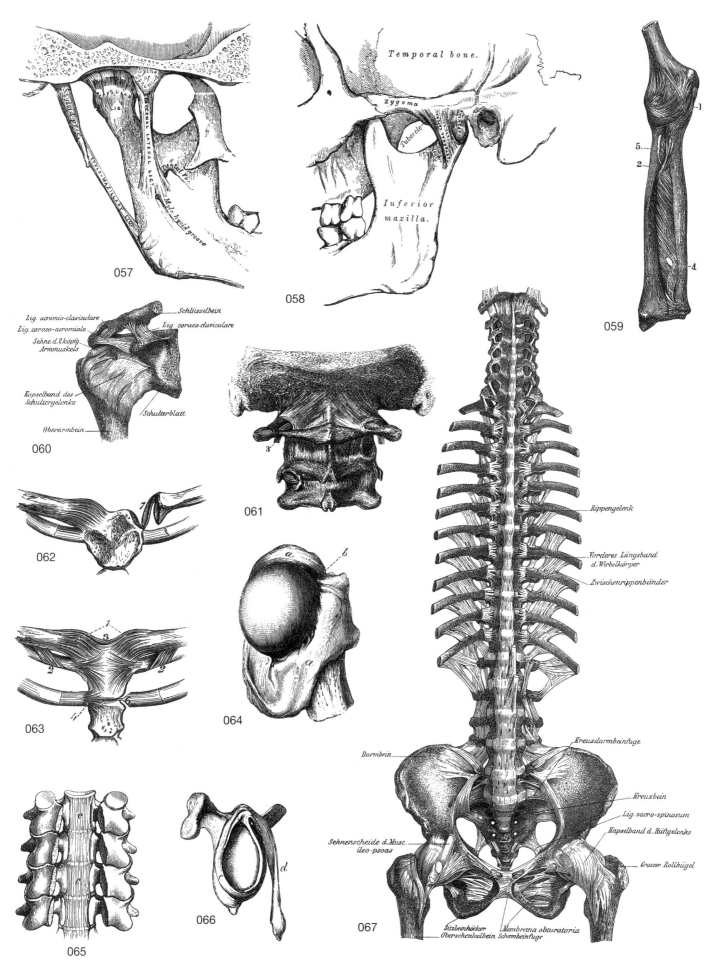

057

058

Temporal bone.

Zygoma

Tubercle

Inferior maxilla.

Mylo hyoid groove

059

060

Lig. acromio-claviculare
Lig. coraco-acromiale
Sehne d. 2 köpfig.
Armmuskels

Schlüsselbein
Lig. coraco-claviculare

Kapselband des
Schultergelenks

Schulterblatt

Oberarmbein

061

062

063

064

065

066

067

Rippengelenk

Vorderes Längsband
d. Wirbelkörper

Zwischenrippenbänder

Kreuzdarmbeinfuge

Darmbein

Kreuzbein

Lig. sacro-spinosum

Kapselband d. Hüftgelenks

Sehnenscheide d. Musc.
ileo-psoas

Grosser Rollhügel

Sitzbeinhöcker
Oberschenkelbein

Membrana obturatoria
Schambeinfuge

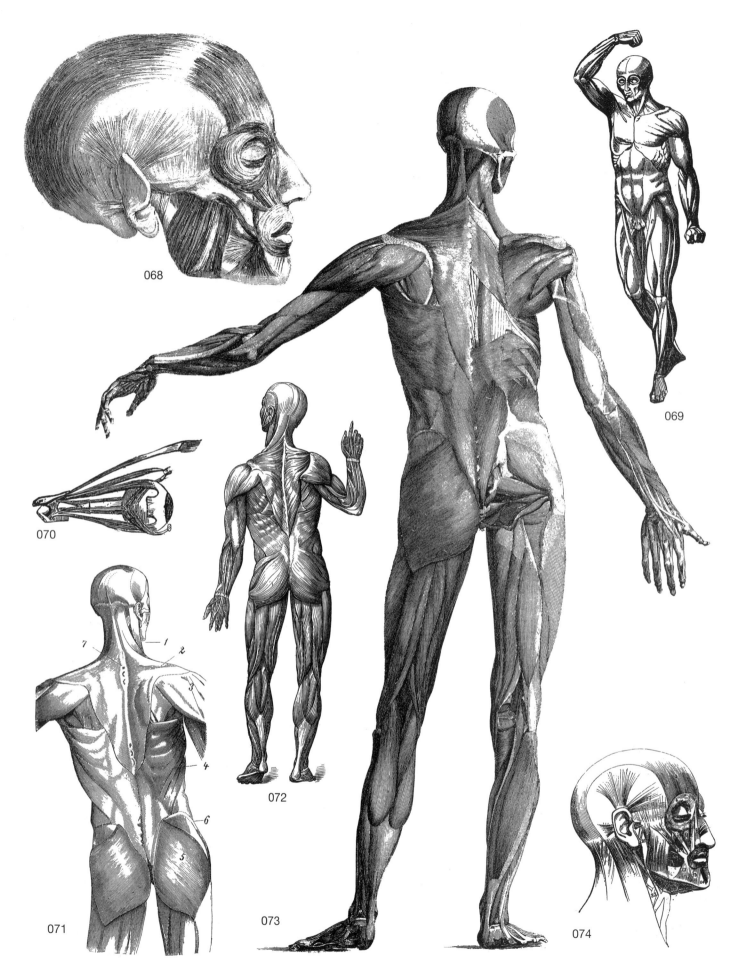

068

069

070

071

072

073

074

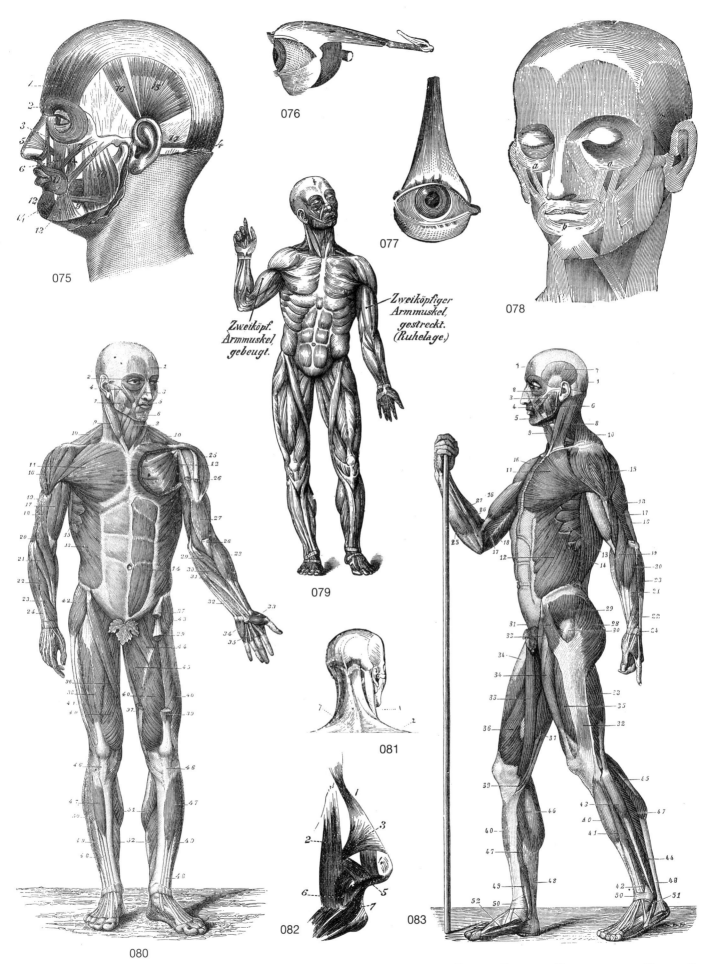

076

077

075

Zweiköpfiger
Armmuskel,
gestreckt.
(Ruhelage.)

Zweiköpf.
Armmuskel
gebeugt.

078

079

081

082

083

080

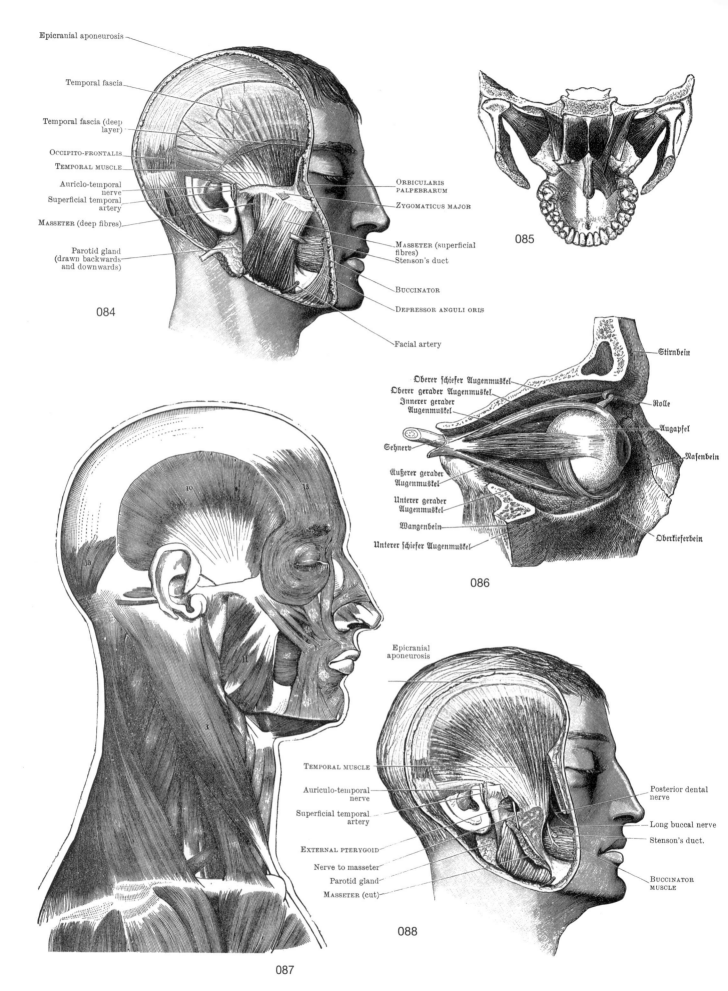

Epicranial aponeurosis

Temporal fascia

Temporal fascia (deep layer)

OCCIPITO-FRONTALIS

TEMPORAL MUSCLE

Auriclo-temporal nerve

Superficial temporal artery

MASSETER (deep fibres)

Parotid gland (drawn backwards and downwards)

084

ORBICULARIS PALPEBRARUM

ZYGOMATICUS MAJOR

MASSETER (superficial fibres)

Stenson's duct

BUCCINATOR

DEPRESSOR ANGULI ORIS

Facial artery

085

Stirnbein

Oberer schiefer Augenmuskel

Oberer gerader Augenmuskel

Innerer gerader Augenmuskel

Sehnerv

Äußerer gerader Augenmuskel

Unterer gerader Augenmuskel

Wangenbein

Unterer schiefer Augenmuskel

Rolle

Augapfel

Nasenbein

Oberkieferbein

086

087

Epicranial aponeurosis

TEMPORAL MUSCLE

Auriculo-temporal nerve

Superficial temporal artery

EXTERNAL PTERYGOID

Nerve to masseter

Parotid gland

MASSETER (cut)

Posterior dental nerve

Long buccal nerve

Stenson's duct.

BUCCINATOR MUSCLE

088

10 MUSCLES AND FASCIA: THE HEAD

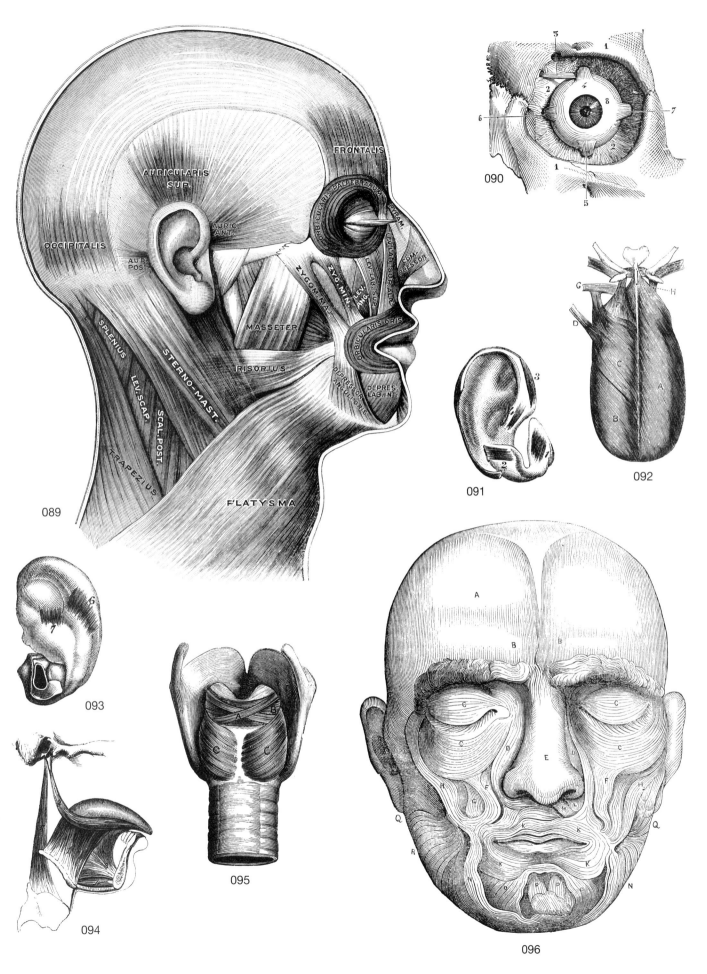

089

090

091

092

093

094

095

096

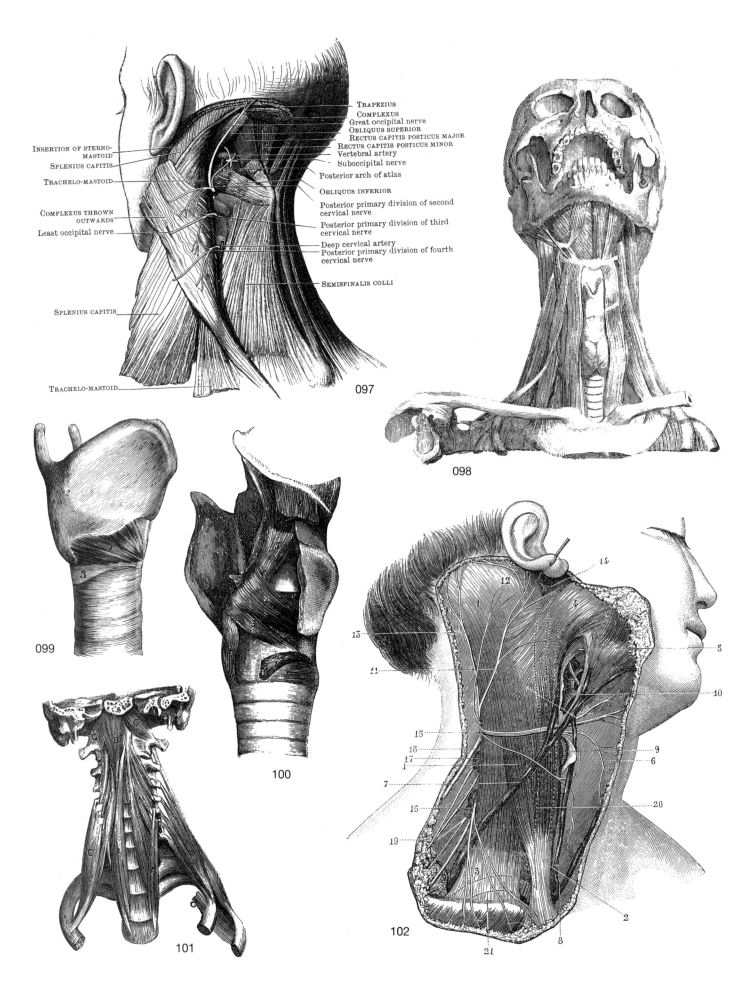

TRAPEZIUS
COMPLEXUS
Great occipital nerve
OBLIQUUS SUPERIOR
RECTUS CAPITIS POSTICUS MAJOR
RECTUS CAPITIS POSTICUS MINOR
Vertebral artery
Suboccipital nerve
Posterior arch of atlas

OBLIQUUS INFERIOR

Posterior primary division of second
cervical nerve
Posterior primary division of third
cervical nerve
Deep cervical artery
Posterior primary division of fourth
cervical nerve

SEMISPINALIS COLLI

INSERTION OF STERNO-
MASTOID
SPLENIUS CAPITIS

TRACHELO-MASTOID

COMPLEXUS THROWN
OUTWARDS

Least occipital nerve

SPLENIUS CAPITIS

TRACHELO-MASTOID

097

098

099

100

101

102

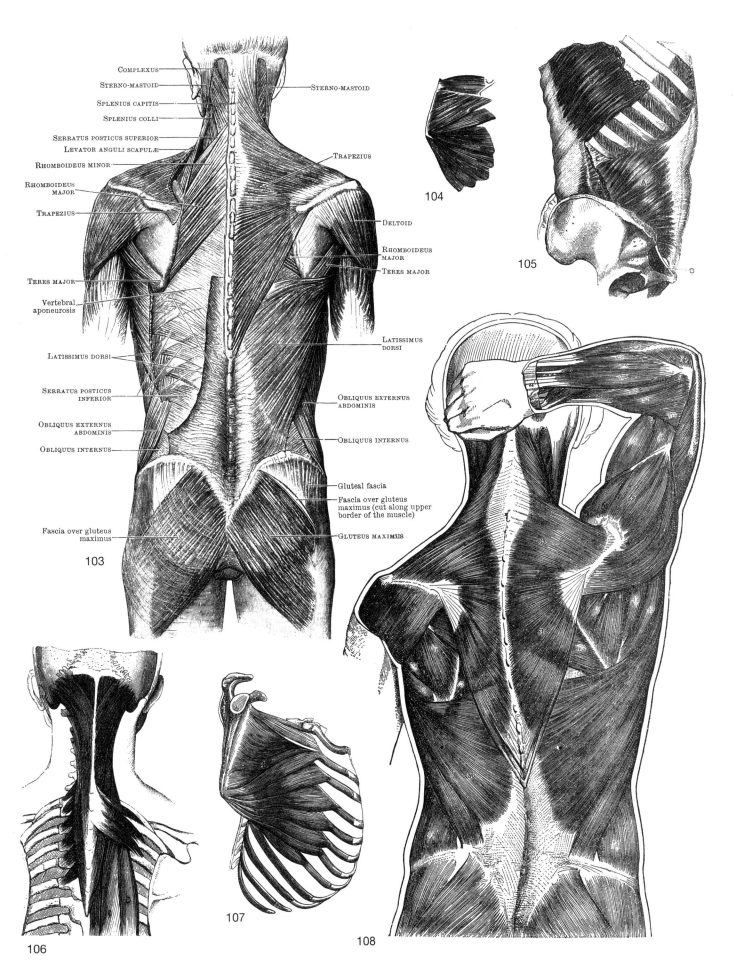

COMPLEXUS
STERNO-MASTOID
SPLENIUS CAPITIS
SPLENIUS COLLI
SERRATUS POSTICUS SUPERIOR
LEVATOR ANGULI SCAPULÆ
RHOMBOIDEUS MINOR
RHOMBOIDEUS MAJOR
TRAPEZIUS
TERES MAJOR
Vertebral aponeurosis
LATISSIMUS DORSI
SERRATUS POSTICUS INFERIOR
OBLIQUUS EXTERNUS ABDOMINIS
OBLIQUUS INTERNUS
Fascia over gluteus maximus

STERNO-MASTOID
TRAPEZIUS
DELTOID
RHOMBOIDEUS MAJOR
TERES MAJOR
LATISSIMUS DORSI
OBLIQUUS EXTERNUS ABDOMINIS
OBLIQUUS INTERNUS
Gluteal fascia
Fascia over gluteus maximus (cut along upper border of the muscle)
GLUTEUS MAXIMUS

103

104

105

106

107

108

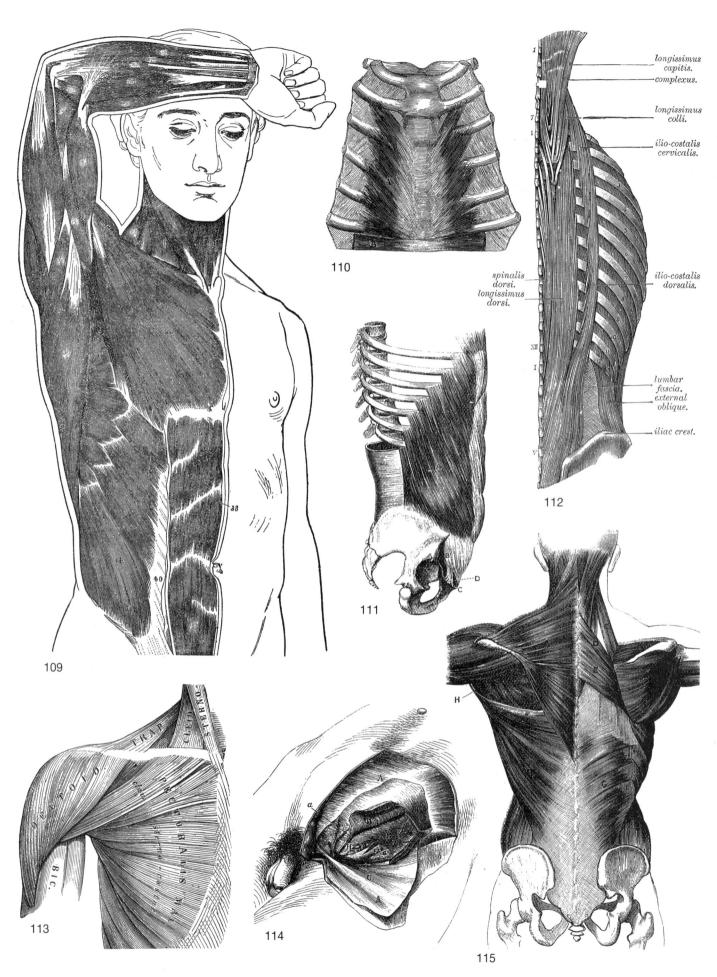

longissimus capitis.
complexus.

longissimus colli.

ilio-costalis cervicalis.

spinalis dorsi.
longissimus dorsi.

ilio-costalis dorsalis.

lumbar fascia.
external oblique.

iliac crest.

109

110

111

112

113

114

115

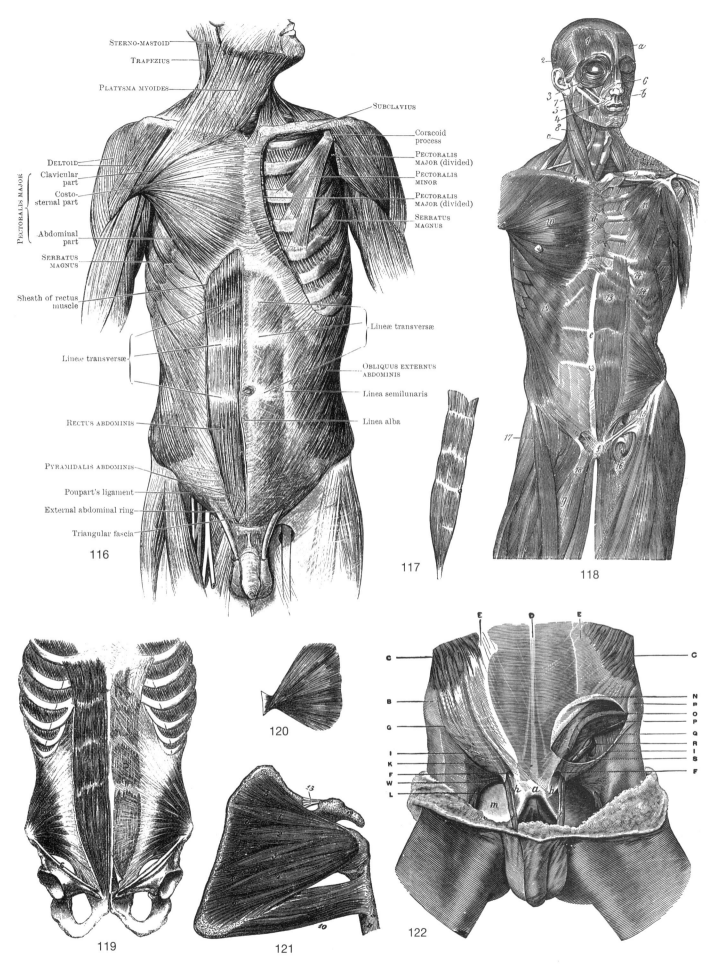

STERNO-MASTOID

TRAPEZIUS

PLATYSMA MYOIDES

SUBCLAVIUS

Coracoid process

DELTOID

PECTORALIS MAJOR (divided)

Clavicular part

PECTORALIS MINOR

Costo-sternal part

PECTORALIS MAJOR (divided)

Abdominal part

SERRATUS MAGNUS

SERRATUS MAGNUS

Sheath of rectus muscle

Lineæ transversæ

Lineæ transversæ

OBLIQUUS EXTERNUS ABDOMINIS

Linea semilunaris

RECTUS ABDOMINIS

Linea alba

PYRAMIDALIS ABDOMINIS

Poupart's ligament

External abdominal ring

Triangular fascia

116

117

118

119

120

121

122

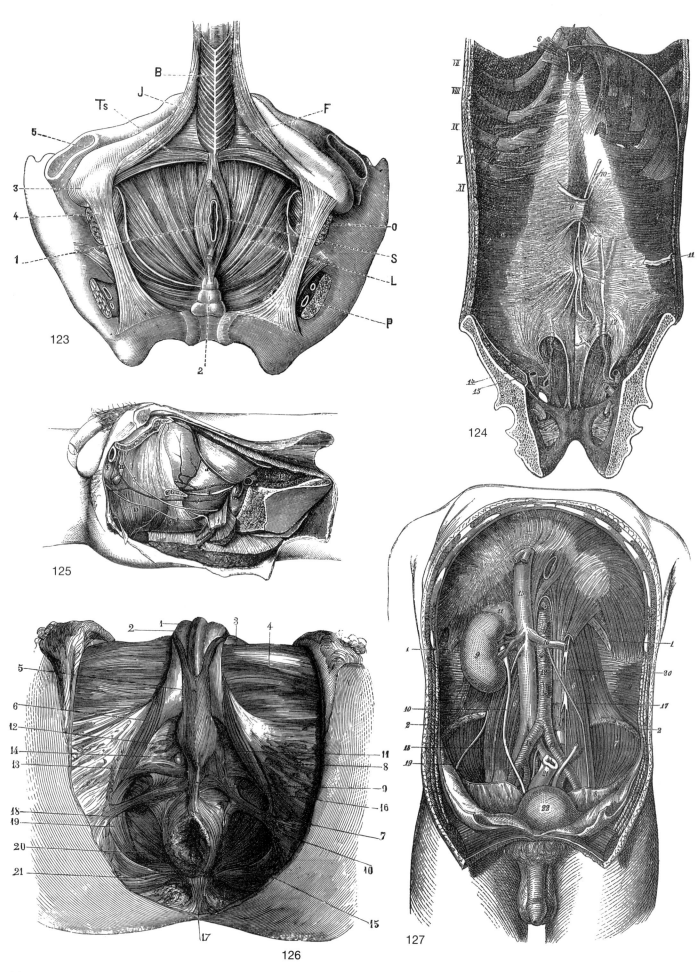

123

124

125

126

127

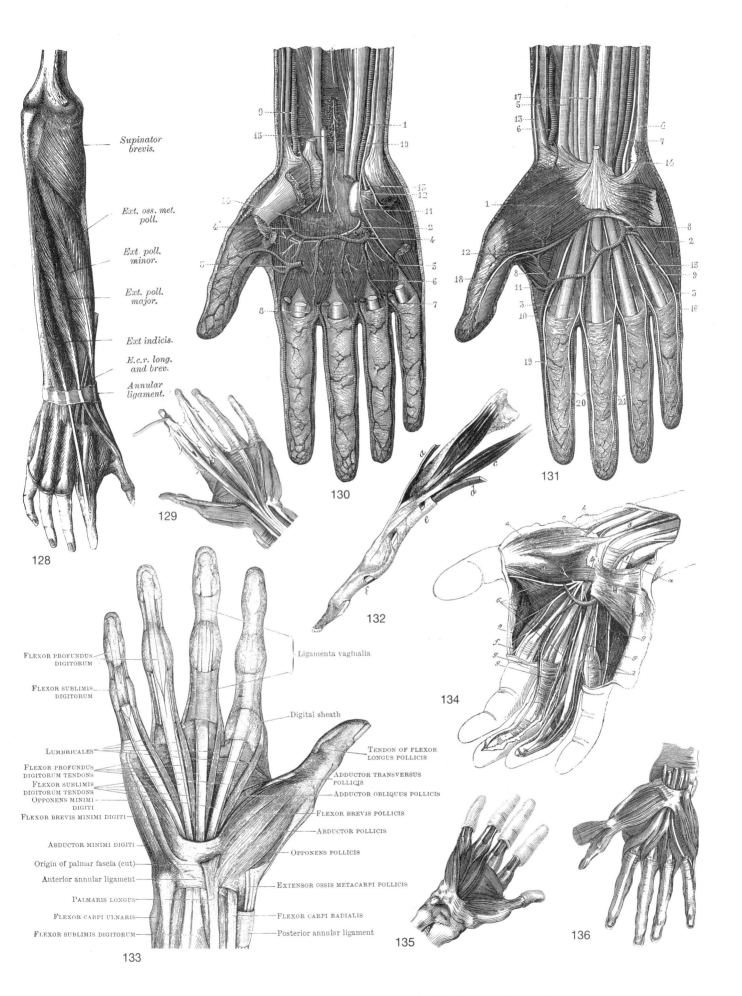

Supinator brevis.

Ext. oss. met. poll.

Ext. poll. minor.

Ext. poll. major.

Ext indicis.

E.c.r. long. and brev.

Annular ligament.

128

129

130

131

132

134

FLEXOR PROFUNDUS DIGITORUM

FLEXOR SUBLIMIS DIGITORUM

Ligamenta vaginalia

Digital sheath

LUMBRICALES

FLEXOR PROFUNDUS DIGITORUM TENDONS

FLEXOR SUBLIMIS DIGITORUM TENDONS

OPPONENS MINIMI DIGITI

FLEXOR BREVIS MINIMI DIGITI

ABDUCTOR MINIMI DIGITI

Origin of palmar fascia (cut)

Anterior annular ligament

PALMARIS LONGUS

FLEXOR CARPI ULNARIS

FLEXOR SUBLIMIS DIGITORUM

TENDON OF FLEXOR LONGUS POLLICIS

ADDUCTOR TRANSVERSUS POLLICIS

ADDUCTOR OBLIQUUS POLLICIS

FLEXOR BREVIS POLLICIS

ABDUCTOR POLLICIS

OPPONENS POLLICIS

EXTENSOR OSSIS METACARPI POLLICIS

FLEXOR CARPI RADIALIS

Posterior annular ligament

133

135

136

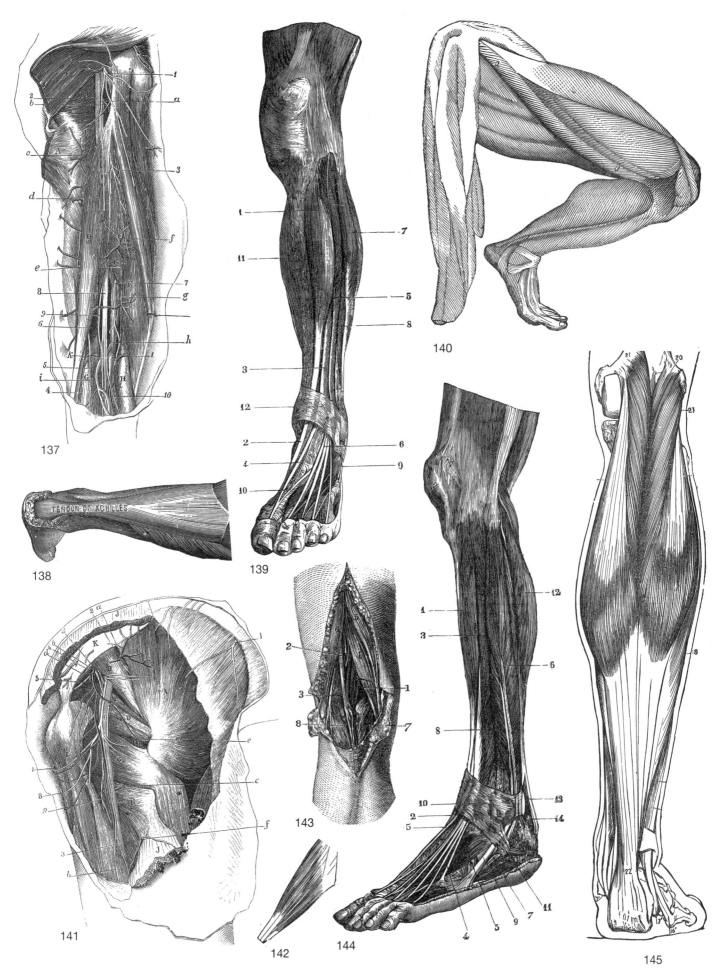

138 TENDON OF ACHILLES

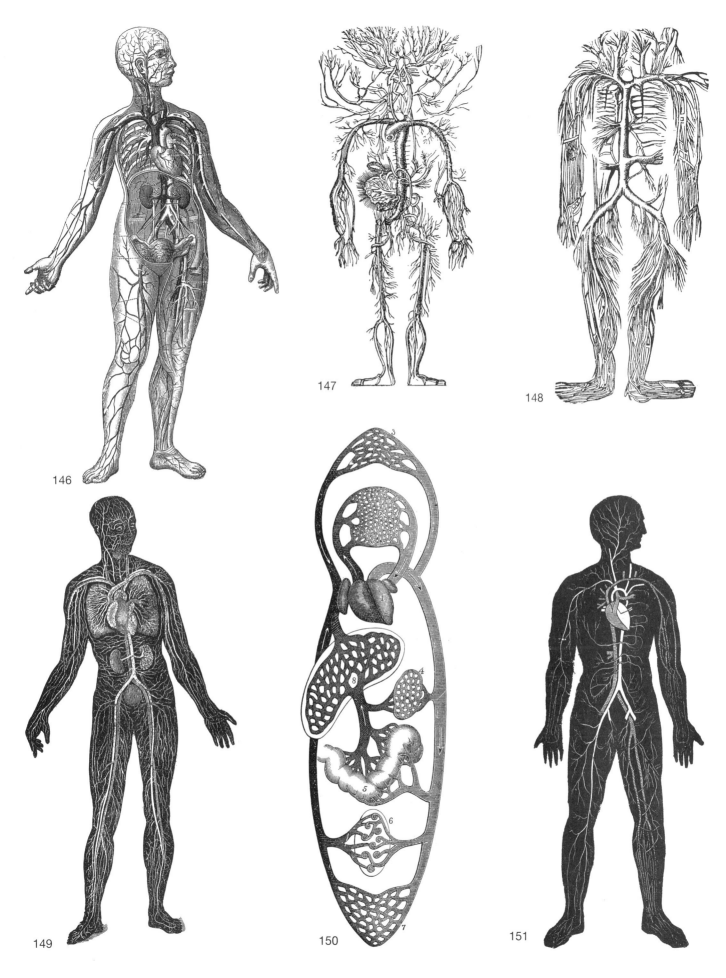

146

147

148

149

150

151

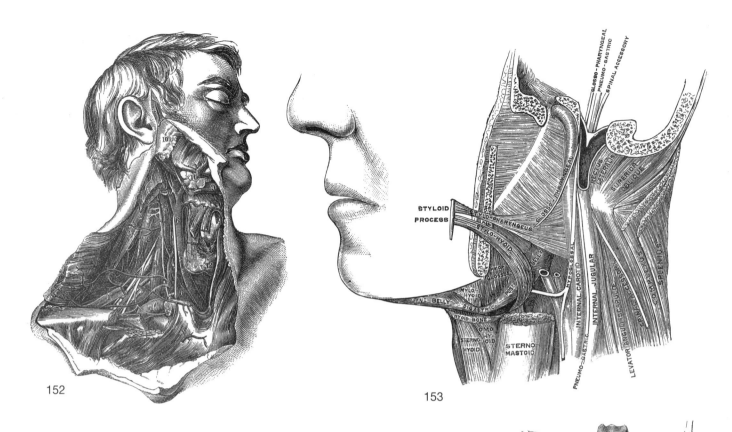

152

153

STYLOID
PROCESS

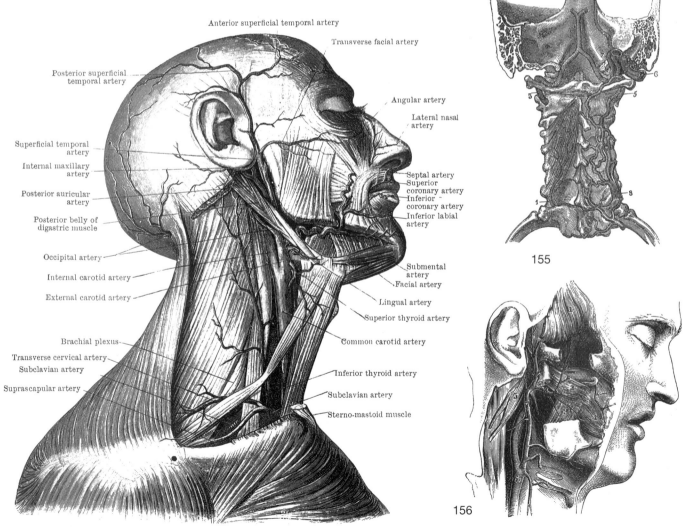

Anterior superficial temporal artery

Transverse facial artery

Posterior superficial
temporal artery

Angular artery

Lateral nasal
artery

Superficial temporal
artery

Internal maxillary
artery

Septal artery
Superior
coronary artery
Inferior
coronary artery
Inferior labial
artery

Posterior auricular
artery

Posterior belly of
digastric muscle

Occipital artery

Submental
artery
Facial artery

Internal carotid artery

External carotid artery

Lingual artery

Superior thyroid artery

Brachial plexus

Common carotid artery

Transverse cervical artery
Subclavian artery

Inferior thyroid artery

Suprascapular artery

Subclavian artery

Sterno-mastoid muscle

155

154

156

20 Blood Vascular System: The Head and Neck

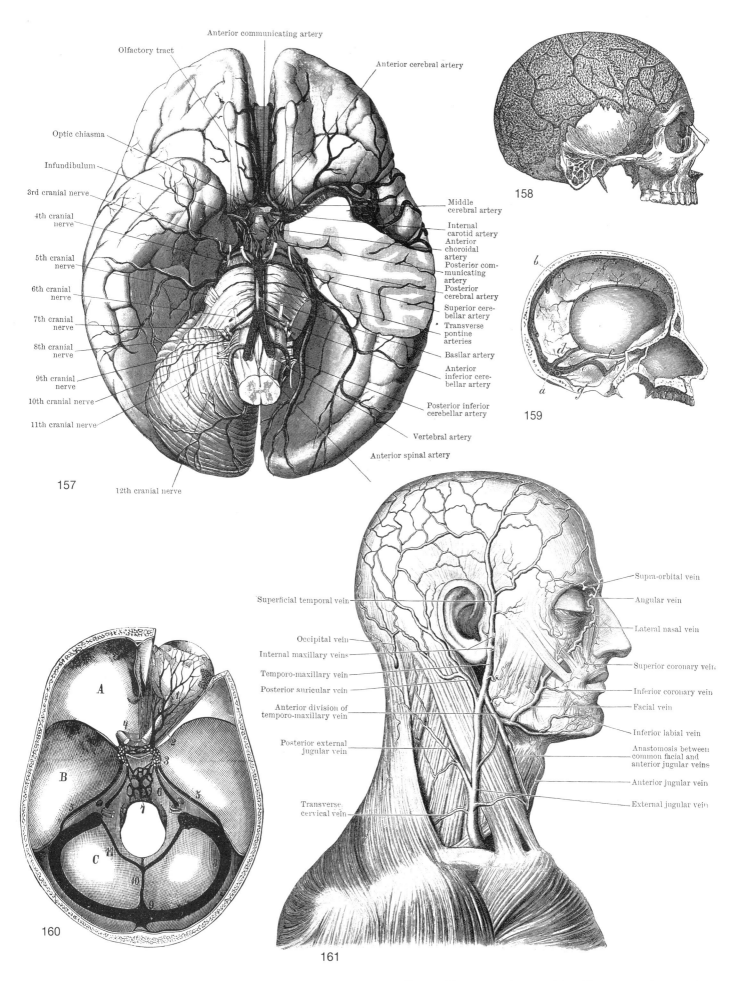

Fig. 157

Anterior communicating artery

Olfactory tract

Optic chiasma

Infundibulum

3rd cranial nerve

4th cranial nerve

5th cranial nerve

6th cranial nerve

7th cranial nerve

8th cranial nerve

9th cranial nerve

10th cranial nerve

11th cranial nerve

12th cranial nerve

Anterior cerebral artery

Middle cerebral artery

Internal carotid artery

Anterior choroidal artery

Posterior communicating artery

Posterior cerebral artery

Superior cerebellar artery

Transverse pontine arteries

Basilar artery

Anterior inferior cerebellar artery

Posterior inferior cerebellar artery

Vertebral artery

Anterior spinal artery

157

158

159

160

A

B

C

161

Superficial temporal vein

Occipital vein

Internal maxillary veins

Temporo-maxillary vein

Posterior auricular vein

Anterior division of temporo-maxillary vein

Posterior external jugular vein

Transverse cervical vein

Supra-orbital vein

Angular vein

Lateral nasal vein

Superior coronary vein

Inferior coronary vein

Facial vein

Inferior labial vein

Anastomosis between common facial and anterior jugular veins

Anterior jugular vein

External jugular vein

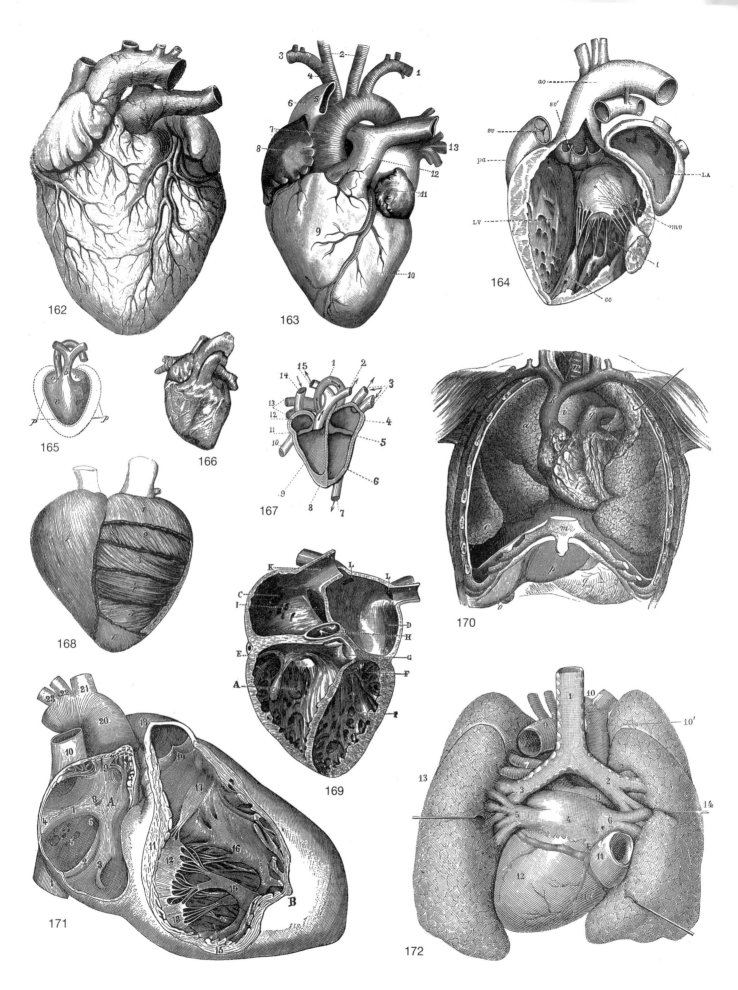

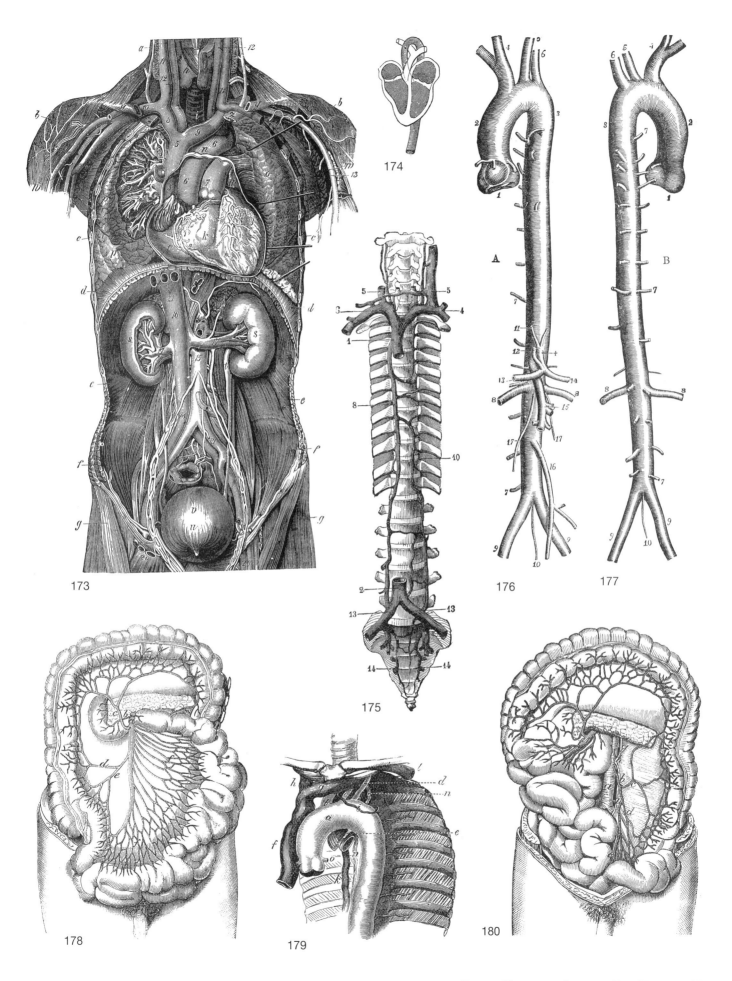

173

174

175

176

177

178

179

180

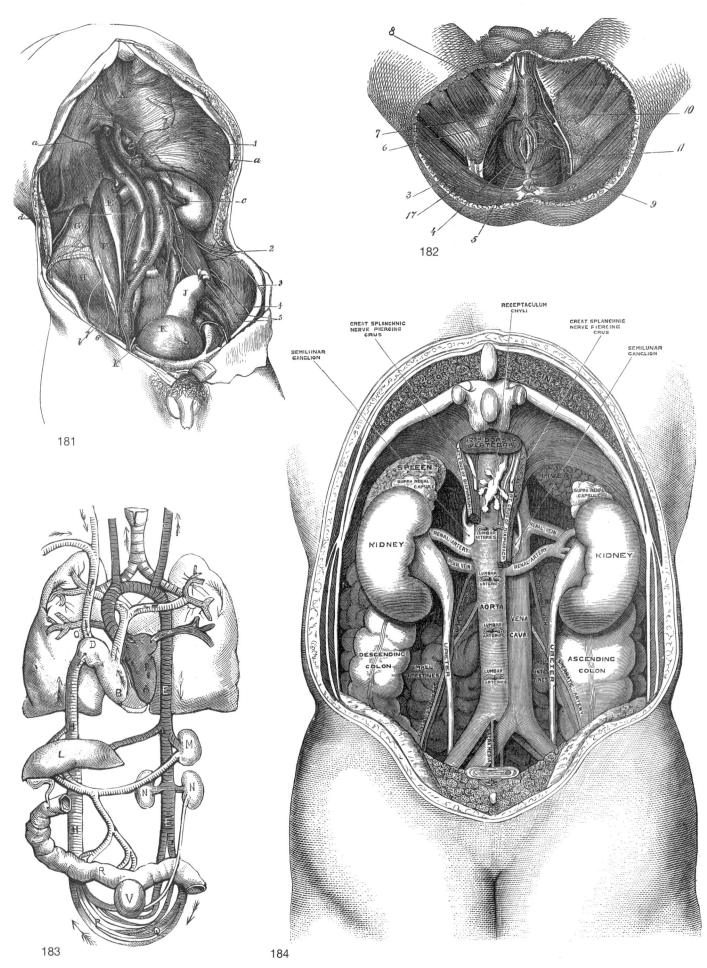

181

182

183 184

Figure 184 labels: RECEPTACULUM CHYLI, GREAT SPLANCHNIC NERVE PIERCING CRUS, SEMILUNAR GANGLION, SPLEEN, SUPRA RENAL CAPSULE, LIVER, SUPRA RENAL CAPSULE, KIDNEY, RENAL ARTERY, RENAL VEIN, RENAL VEIN, RENAL ARTERY, KIDNEY, 12TH DORSAL VERTEBRA, LUMBAR ARTERIES, AORTA, LUMBAR ARTERIES, VENA CAVA, DESCENDING COLON, SMALL INTESTINES, URETER, LUMBAR ARTERIES, URETER, SPERMATIC ARTERY, ASCENDING COLON

24 BLOOD VASCULAR SYSTEM: THE TRUNK

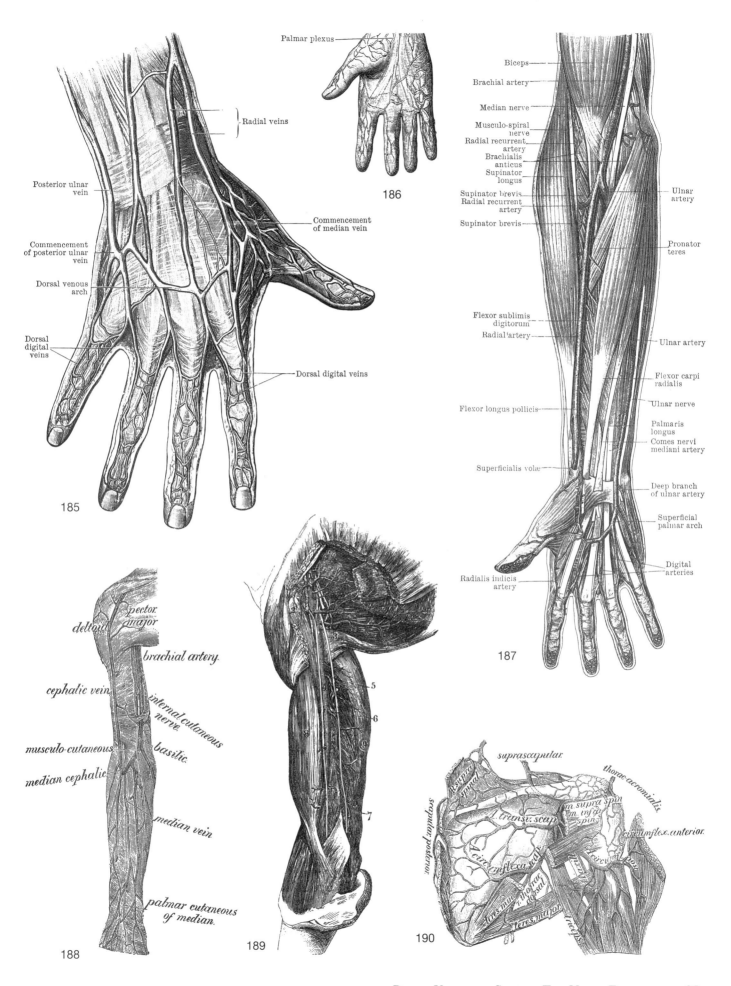

Palmar plexus

Radial veins

Posterior ulnar vein

Commencement of posterior ulnar vein

Dorsal venous arch

Dorsal digital veins

Commencement of median vein

Dorsal digital veins

185

186

Biceps

Brachial artery

Median nerve

Musculo-spiral nerve
Radial recurrent artery
Brachialis anticus
Supinator longus
Supinator brevis
Radial recurrent artery
Supinator brevis

Ulnar artery

Pronator teres

Flexor sublimis digitorum
Radial artery

Ulnar artery

Flexor carpi radialis

Ulnar nerve

Flexor longus pollicis

Palmaris longus
Comes nervi mediani artery

Superficialis volæ

Deep branch of ulnar artery

Superficial palmar arch

Digital arteries

Radialis indicis artery

187

pector. major
deltoid
brachial artery.
cephalic vein.
internal cutaneous nerve.
musculo-cutaneous
basilic.
median cephalic
median vein.

palmar cutaneous of median.

188

5

6

7

189

suprascapular.
thorac-acromialis.
a. supra spinal
m. supra spin
m. infra spin
scapular. posterior.
A. transv. scap.
circumflex. anterior.
A. circumflex. scap.
a. circumflex. post
teres min.
a. thorac. dorsal.
teres major.
triceps.

190

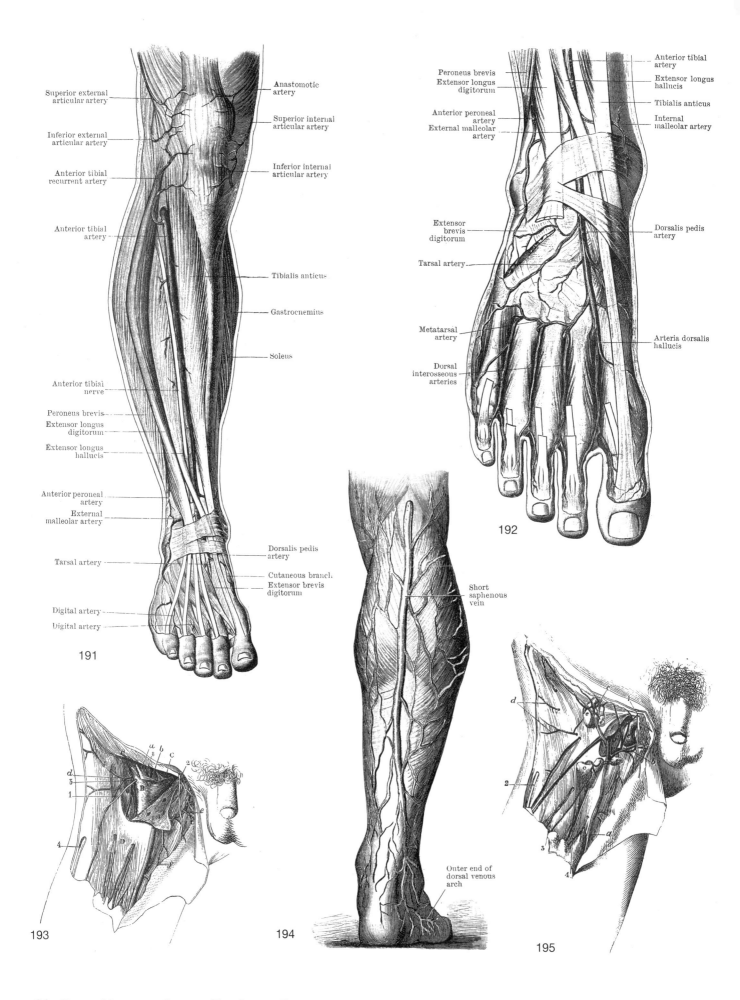

Superior external articular artery

Inferior external articular artery

Anterior tibial recurrent artery

Anterior tibial artery

Anterior tibial nerve

Peroneus brevis

Extensor longus digitorum

Extensor longus hallucis

Anterior peroneal artery

External malleolar artery

Tarsal artery

Digital artery

Digital artery

Anastomotic artery

Superior internal articular artery

Inferior internal articular artery

Tibialis anticus

Gastrocnemius

Soleus

Dorsalis pedis artery

Cutaneous branch

Extensor brevis digitorum

191

Peroneus brevis
Extensor longus digitorum

Anterior peroneal artery
External malleolar artery

Extensor brevis digitorum

Tarsal artery

Metatarsal artery

Dorsal interosseous arteries

Anterior tibial artery

Extensor longus hallucis

Tibialis anticus

Internal malleolar artery

Dorsalis pedis artery

Arteria dorsalis hallucis

192

Short saphenous vein

Outer end of dorsal venous arch

193

194

195

26 BLOOD VASCULAR SYSTEM: THE LOWER EXTREMITIES

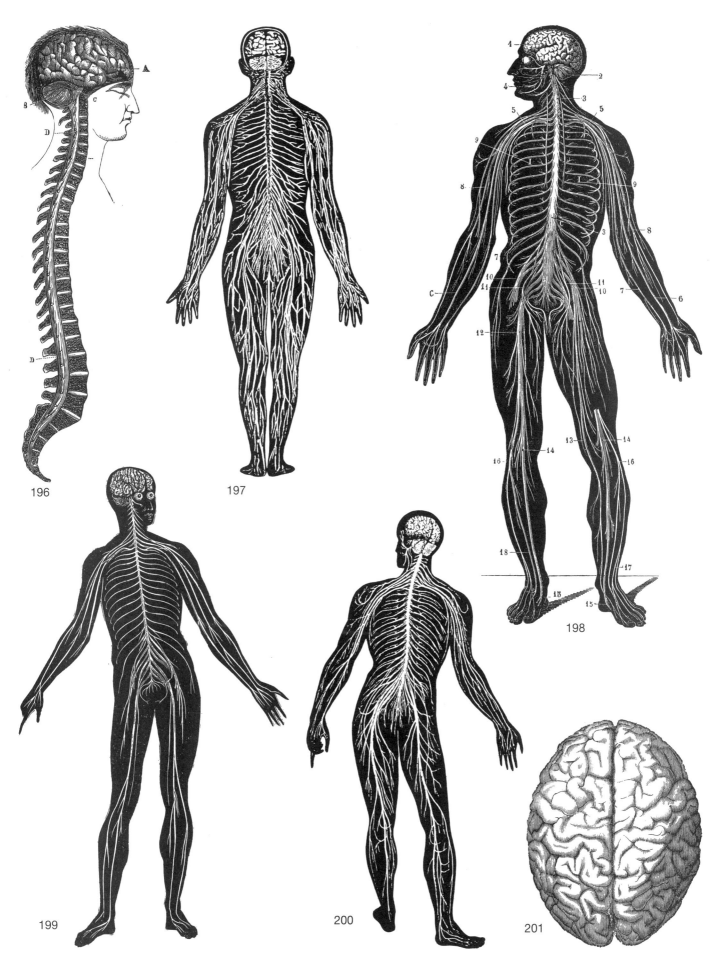

196

197

198

199

200

201

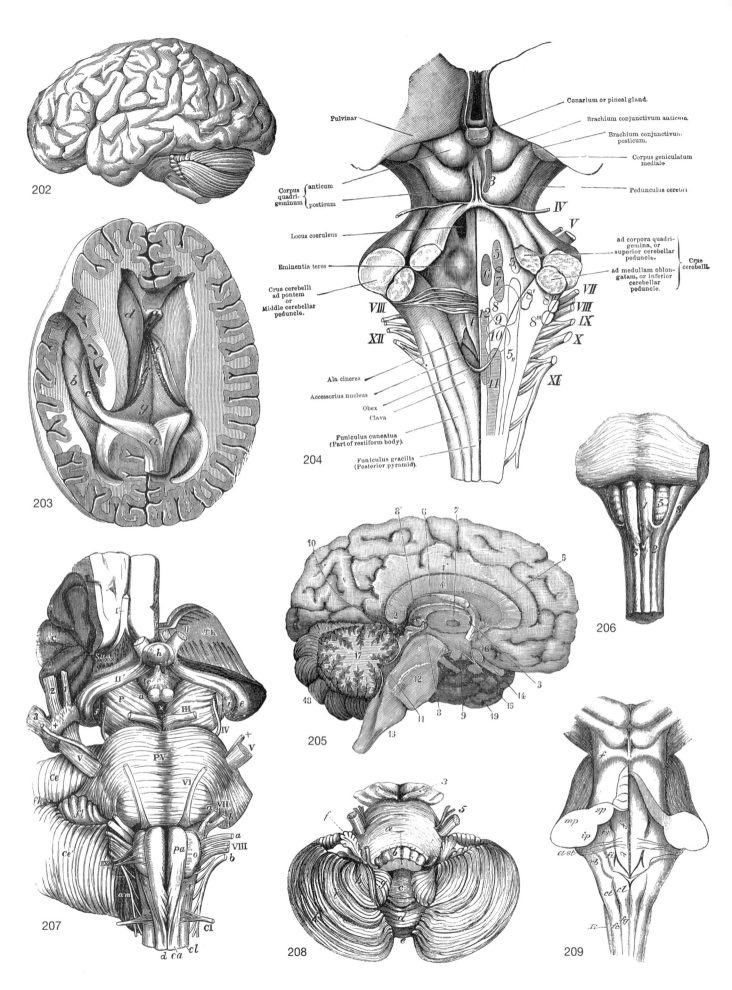

202

203

Pulvinar

Conarium or pineal gland.

Brachium conjunctivum anticum.

Brachium conjunctivum posticum.

Corpus geniculatum mediale

Pedunculus cerebri

Corpus quadri-geminum { anticum / posticum

Locus coeruleus

Eminentia teres

Crus cerebelli ad pontem or Middle cerebellar peduncle.

ad corpora quadri-gemina, or superior cerebellar peduncle.

ad medullam oblon-gatam, or inferior cerebellar peduncle.

Crus cerebelli

Ala cinerea

Accessorius nucleus

Obex

Clava

Funiculus cuneatus (Part of restiform body).

Funiculus gracilis (Posterior pyramid).

204

205

206

207

208

209

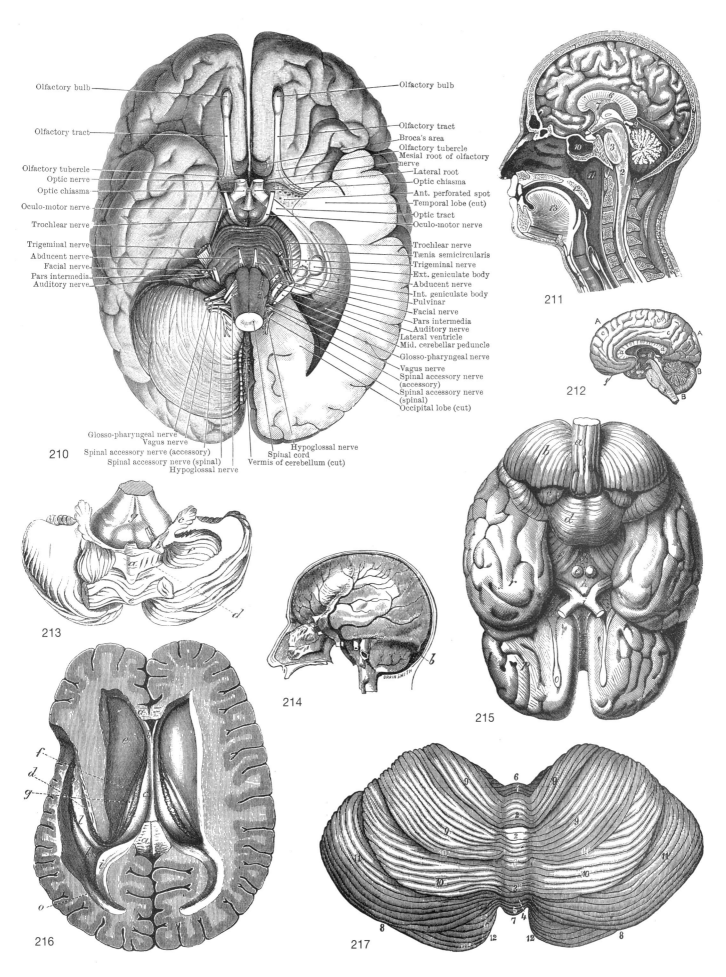

Olfactory bulb

Olfactory tract

Olfactory tubercle
Optic nerve
Optic chiasma
Oculo-motor nerve
Trochlear nerve
Trigeminal nerve
Abducent nerve
Facial nerve
Pars intermedia
Auditory nerve

Olfactory bulb

Olfactory tract
Broca's area
Olfactory tubercle
Mesial root of olfactory nerve
Lateral root
Optic chiasma
Ant. perforated spot
Temporal lobe (cut)
Optic tract
Oculo-motor nerve

Trochlear nerve
Tænia semicircularis
Trigeminal nerve
Ext. geniculate body
Abducent nerve
Int. geniculate body
Pulvinar
Facial nerve
Pars intermedia
Auditory nerve
Lateral ventricle
Mid. cerebellar peduncle
Glosso-pharyngeal nerve
Vagus nerve
Spinal accessory nerve (accessory)
Spinal accessory nerve (spinal)
Occipital lobe (cut)

Glosso-pharyngeal nerve
Vagus nerve
Spinal accessory nerve (accessory)
Spinal accessory nerve (spinal)
Hypoglossal nerve

Hypoglossal nerve
Spinal cord
Vermis of cerebellum (cut)

210

211

212

213

214

215

216

217

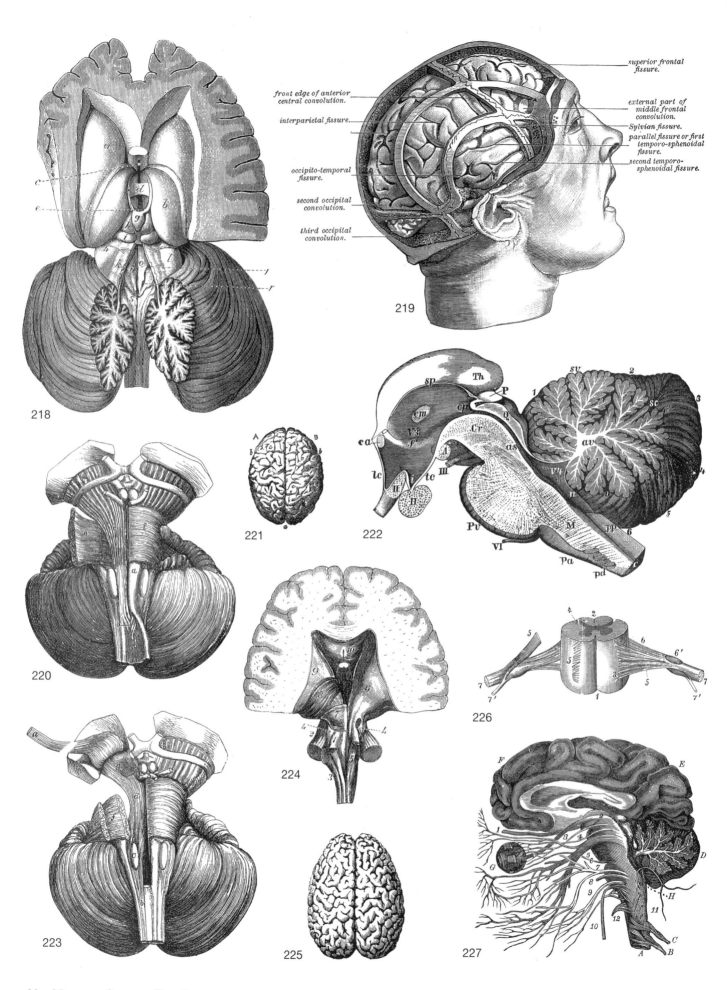

superior frontal
fissure.

front edge of anterior
central convolution.

external part of
middle frontal
convolution.

interparietal fissure.

Sylvian fissure.
parallel fissure or first
temporo-sphenoidal
fissure.
second temporo-
sphenoidal fissure.

occipito-temporal
fissure.

second occipital
convolution.

third occipital
convolution.

218

219

220

221

222

223

224

225

226

227

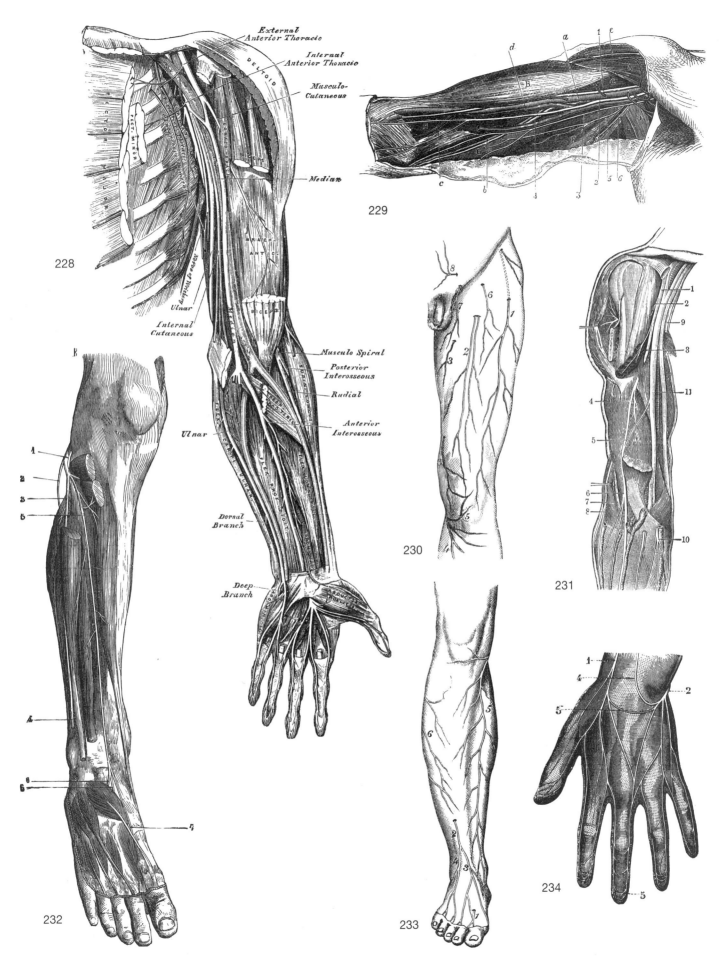

228

External Anterior Thoracic
Internal Anterior Thoracic
Musculo-Cutaneous

DELTOID
PECTOR. MINOR

Median

Ulnar
Internal Cutaneous

BICEPS

Ulnar

Dorsal Branch

Deep Branch

Musculo Spiral
Posterior Interosseous
Radial
Anterior Interosseous

229

230

231

232

233

234

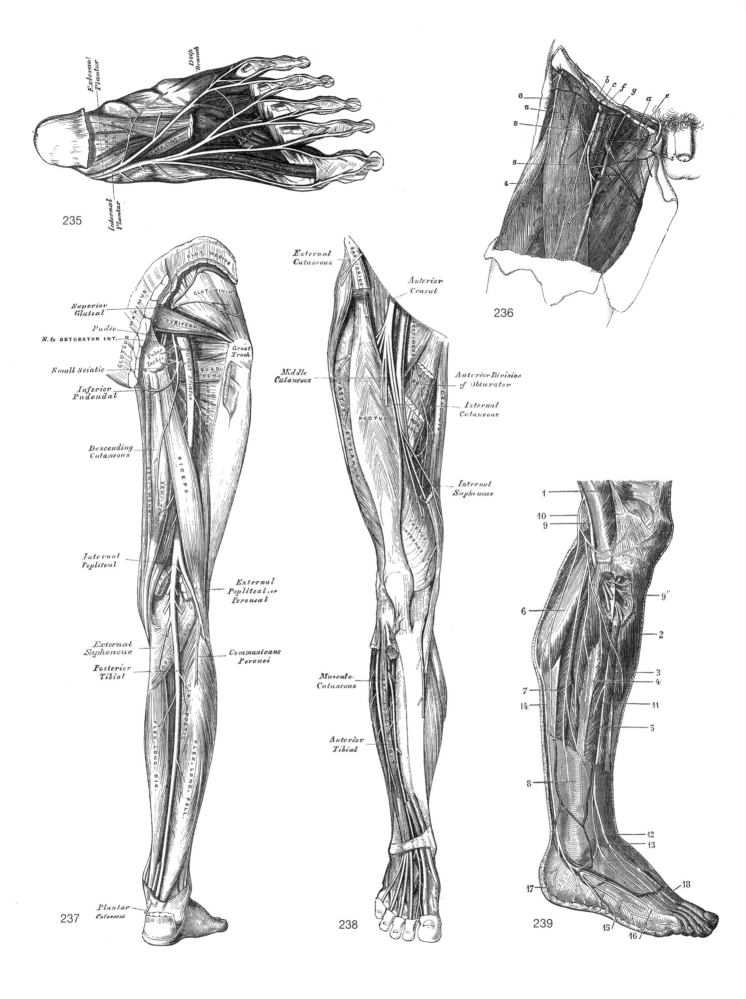

235

External Plantar
Deep Branch
Internal Plantar

236

b c f g a e
6
5
2
3
4

237

Superior Gluteal
Pudic
N. to OBTURATOR INT.
Small Sciatic
Inferior Pudendal
Descending Cutaneous
Internal Popliteal
External Saphenous
Posterior Tibial
Plantar Cutaneous
CLUT. RECTUS
CLUT. MINIM.
PYRIFORMIS
Great Troch.
Tuber Ischii
GEM. SUPER.
OBTUR. INTER.
GEM. INFER.
QUAD. FEM.
ADDUCTOR
BICEPS
SEMI-TENDINOSUS
SEMI-MEMB.
POPLIT.
TIB. POSTIC.
FLEX. LONG. DIG.
FLEX. LONG. POLL.
External Popliteal or Peroneal
Communicans Peronei

238

External Cutaneous
Anterior Crural
Middle Cutaneous
Anterior Divisions of Obturator
Internal Cutaneous
Internal Saphenous
Musculo-Cutaneous
Anterior Tibial
SARTORIUS
VASTUS EXTERNUS
RECTUS
VASTUS INTERNUS
EXT. LONG. DIG.

239

1
10
9
6
7
14
8
17
9"
2
3
4
11
5
12
13
18
15
16

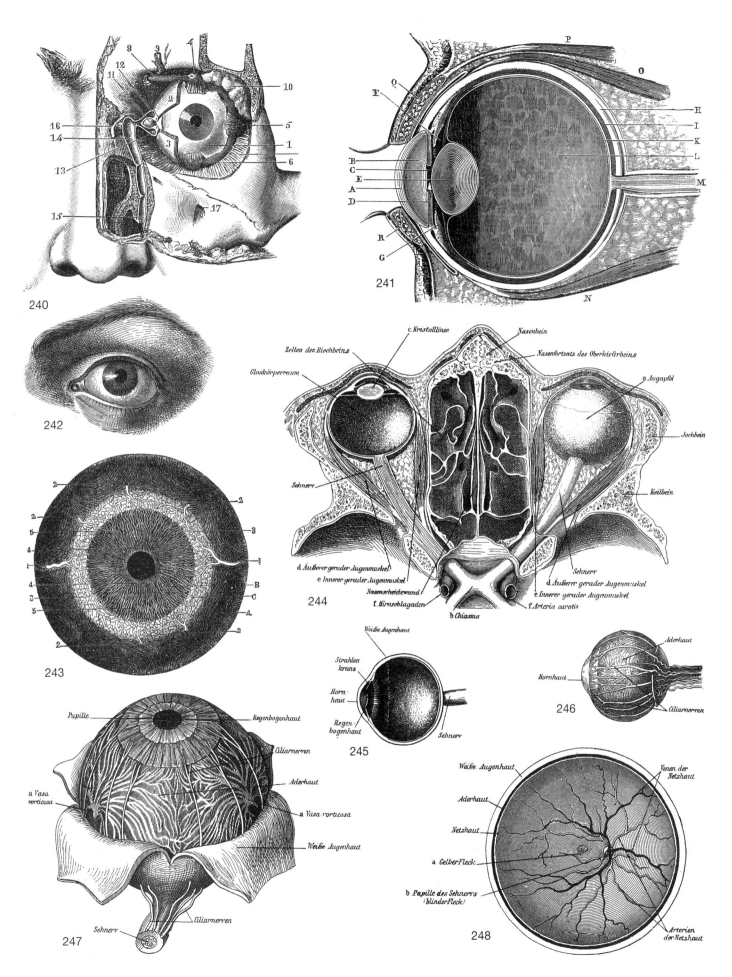

240

241

242

243

244

c Kristalllinse
Zellen des Riechbeins
Glaskörperraum
Sehnerv
d Äußerer gerader Augenmuskel
e Innerer gerader Augenmuskel
Nasenscheidewand
f Hirnschlagader
b Chiasma
Nasenbein
Nasenfortsatz des Oberkieferbeins
a Augapfel
Jochbein
Keilbein
Sehnerv
d Äußerer gerader Augenmuskel
e Innerer gerader Augenmuskel
f Arteria carotis

245

Weiße Augenhaut
Strahlen kranz
Horn haut
Regen bogenhaut
Sehnerv

246

Aderhaut
Hornhaut
Ciliarnerven

247

Pupille
Regenbogenhaut
Ciliarnerven
Aderhaut
a Vasa vorticosa
a Vasa vorticosa
Weiße Augenhaut
Sehnerv
Ciliarnerven

248

Weiße Augenhaut
Aderhaut
Netzhaut
a Gelber Fleck
b Papille des Sehnervs (blinder Fleck)
Venen der Netzhaut
Arterien der Netzhaut

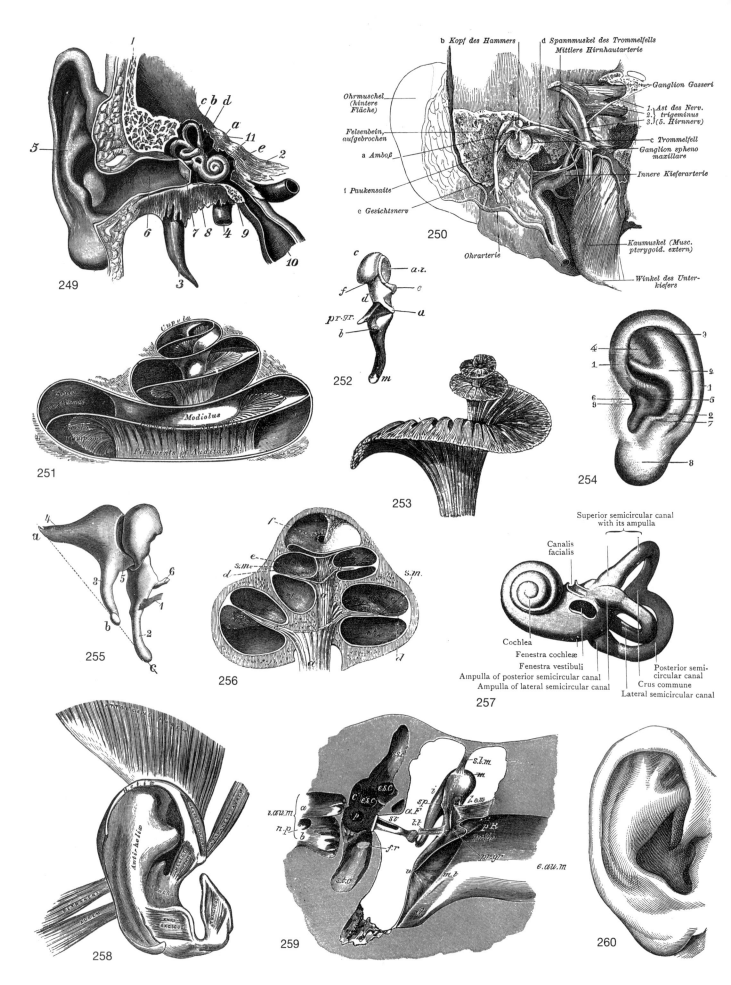

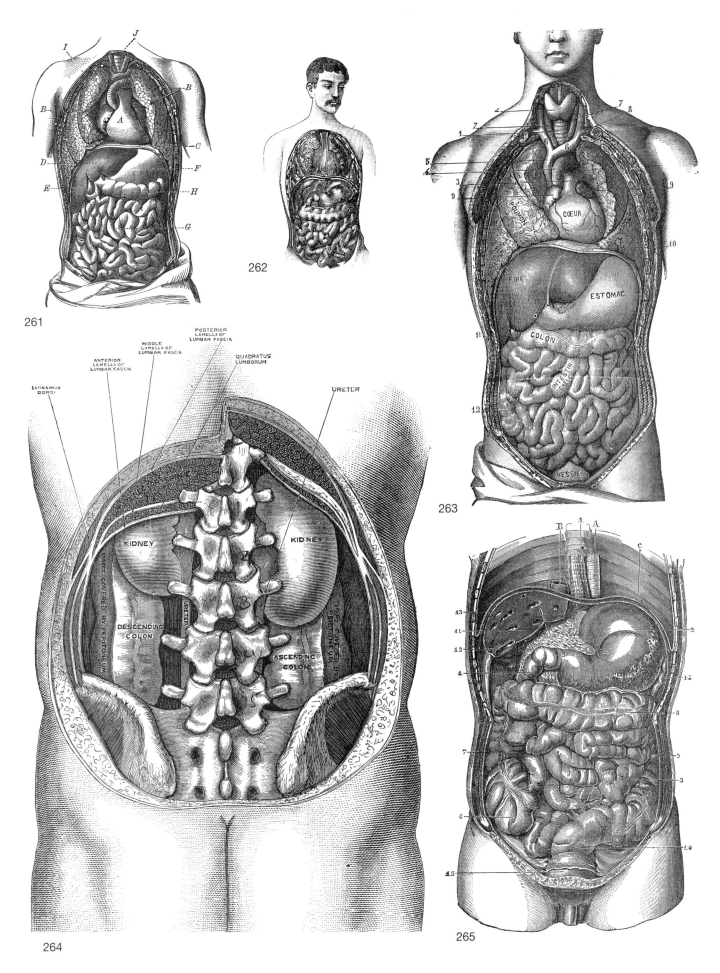

261

262

263

264

265

ANTERIOR
LAMELLA OF
LUMBAR FASCIA

MIDDLE
LAMELLA OF
LUMBAR FASCIA

POSTERIOR
LAMELLA OF
LUMBAR FASCIA

QUADRATUS
LUMBORUM

URETER

LATISSIMUS
DORSI

KIDNEY

KIDNEY

DESCENDING
COLON

URETER

ASCENDING
COLON

PART COVERED BY PERITONEUM

PART COVERED BY PERITONEUM

POUMON

COEUR

FOIE

ESTOMAC

COLON

INTESTIN
GRELE

VESSIE

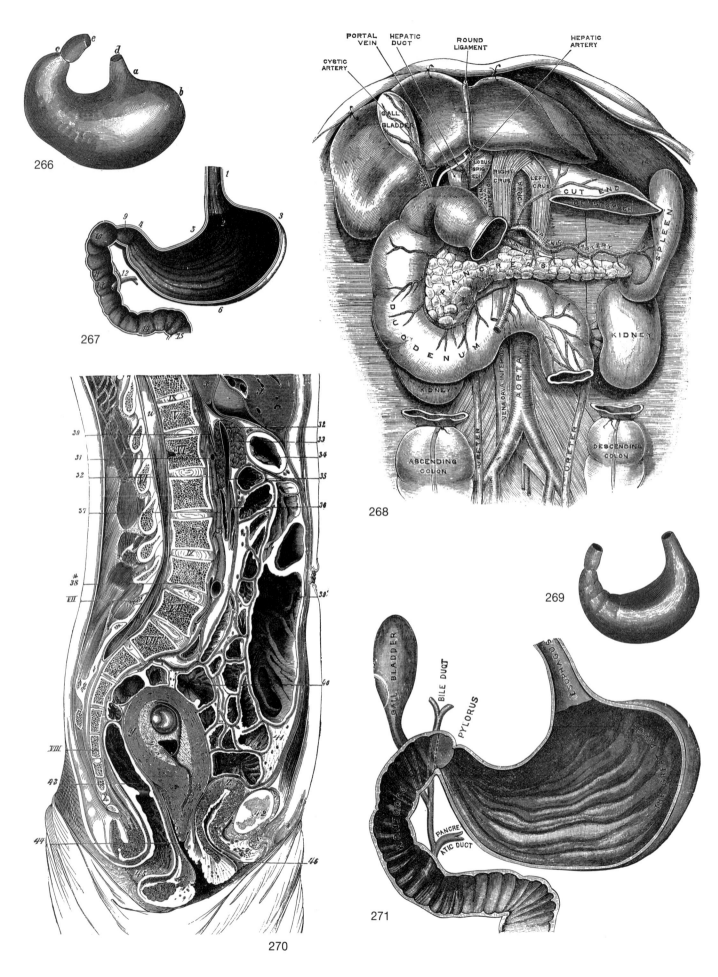

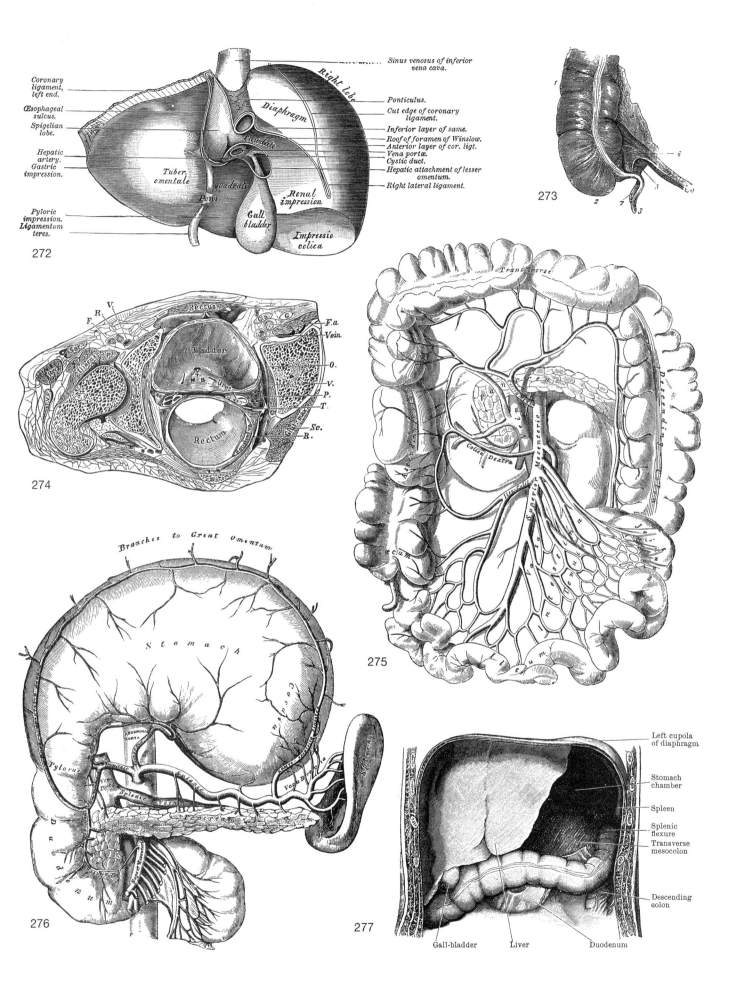

272

Coronary ligament, left end.
Œsophageal sulcus.
Spigelian lobe.
Hepatic artery.
Gastric impression.
Pyloric impression.
Ligamentum teres.

Right lobe
Diaphragm
Caudate
Tuber omentale
Quadrate
Pons
Gall bladder
Renal impression
Impressio colica

Sinus venosus of inferior vena cava.
Ponticulus.
Cut edge of coronary ligament.
Inferior layer of same.
Roof of foramen of Winslow.
Anterior layer of cor. ligt.
Vena portæ.
Cystic duct.
Hepatic attachment of lesser omentum.
Right lateral ligament.

273

274

Rectus.
Bladder
F.a.
Vein.
O.
V.
P.
T.
Sc.
R.
Rectum

275

Transverse
Colica Dextra
Cæcum
Ileum
Superior Mesenteric
Descending
Jejun
Ileum

276

Branches to Great Omentum.
Stomach
Abdominal Aorta
Splenic
Pylorus
Duodenum
Vasa Brevia

277

Left cupola of diaphragm
Stomach chamber
Spleen
Splenic flexure
Transverse mesocolon
Descending colon
Gall-bladder
Liver
Duodenum

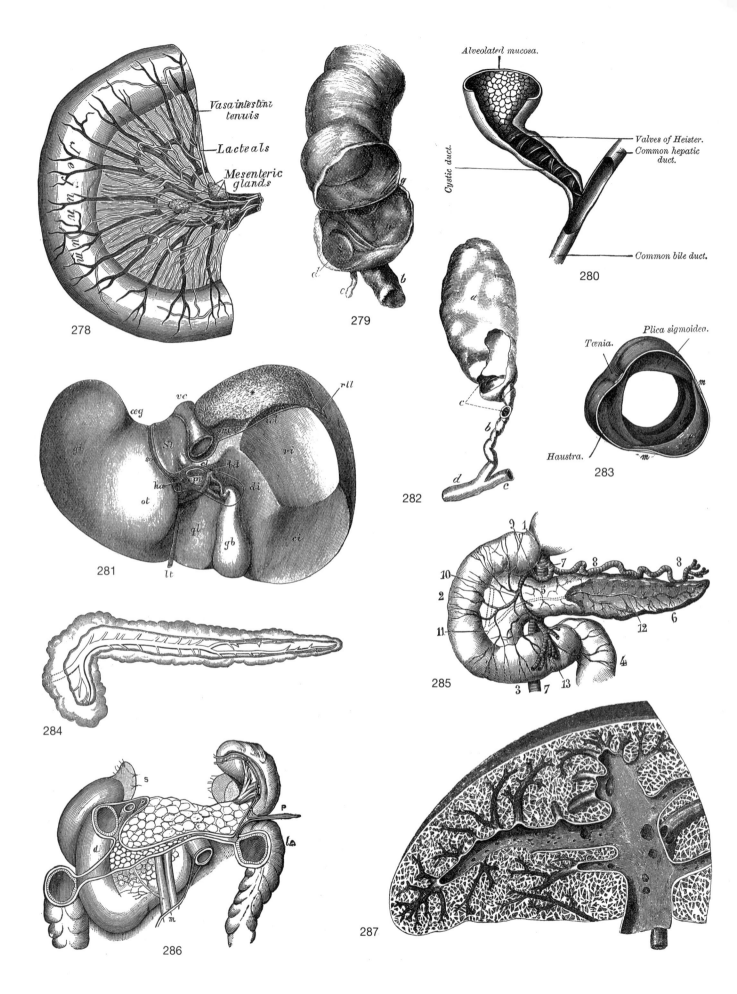

Vasa intestini tenuis

Lacteals

Mesenteric glands

278

279

Alveolated mucosa.

Cystic duct.

Valves of Heister.
Common hepatic duct.

Common bile duct.

280

282

Plica sigmoidea.

Tænia.

Haustra.

283

281

284

285

286

287

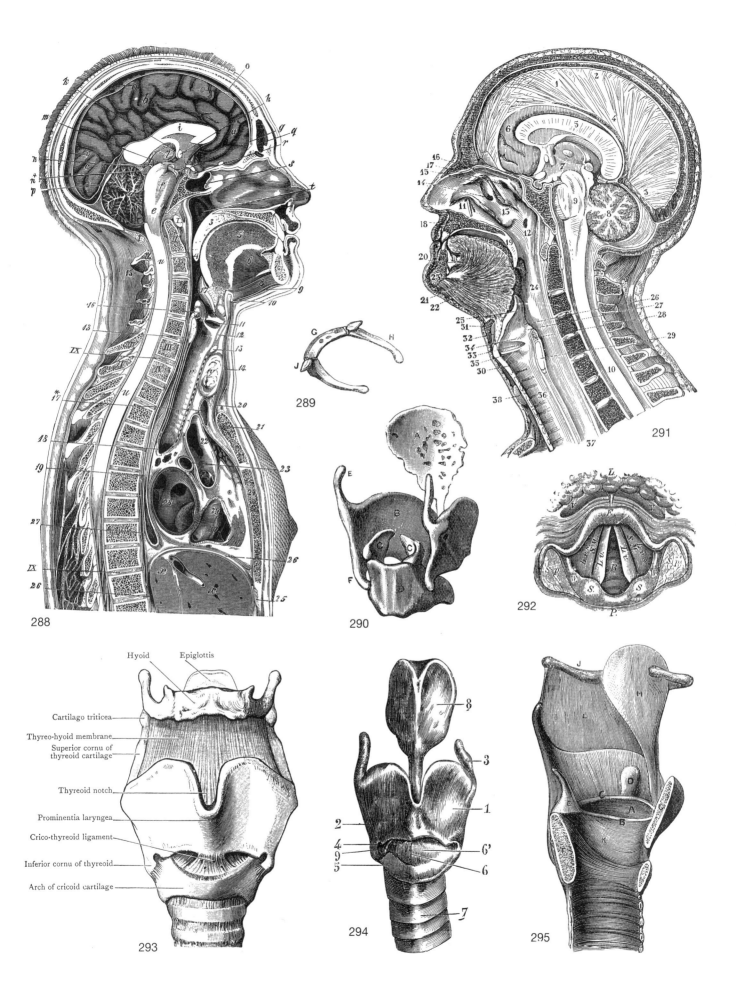

Hyoid

Epiglottis

Cartilago triticea

Thyreo-hyoid membrane

Superior cornu of
thyreoid cartilage

Thyreoid notch

Prominentia laryngea

Crico-thyreoid ligament

Inferior cornu of thyreoid

Arch of cricoid cartilage

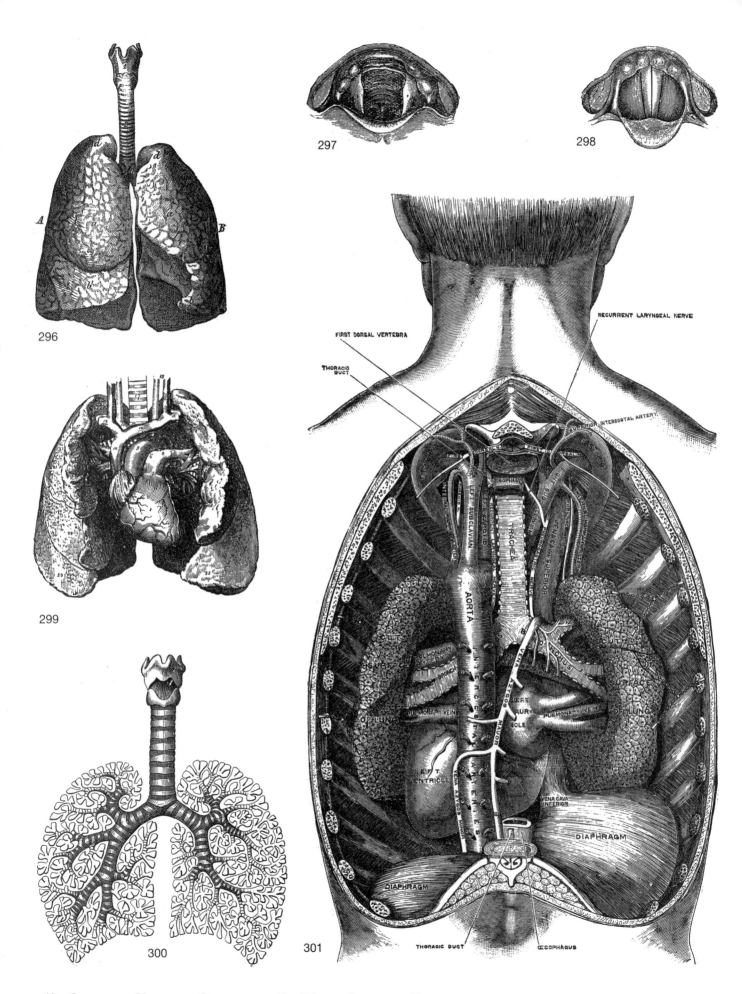

297

298

296

299

300

301

FIRST DORSAL VERTEBRA

THORACIC DUCT

RECURRENT LARYNGEAL NERVE

POSTERIOR INTERCOSTAL ARTERY

OESOPHAGUS

LEFT CAROTID

LEFT SUBCLAVIAN

TRACHEA

VENA CAVA SUPERIOR

AORTA

VENA AZYGOS MAJOR

OF LUNG

PULMONARY VEIN

PULMONARY VEIN

OF LUNG

LEFT AURICLE

LEFT VENTRICLE

VENA AZYGOS MINOR

VENA CAVA INFERIOR

DIAPHRAGM

DIAPHRAGM

THORACIC DUCT

OESOPHAGUS

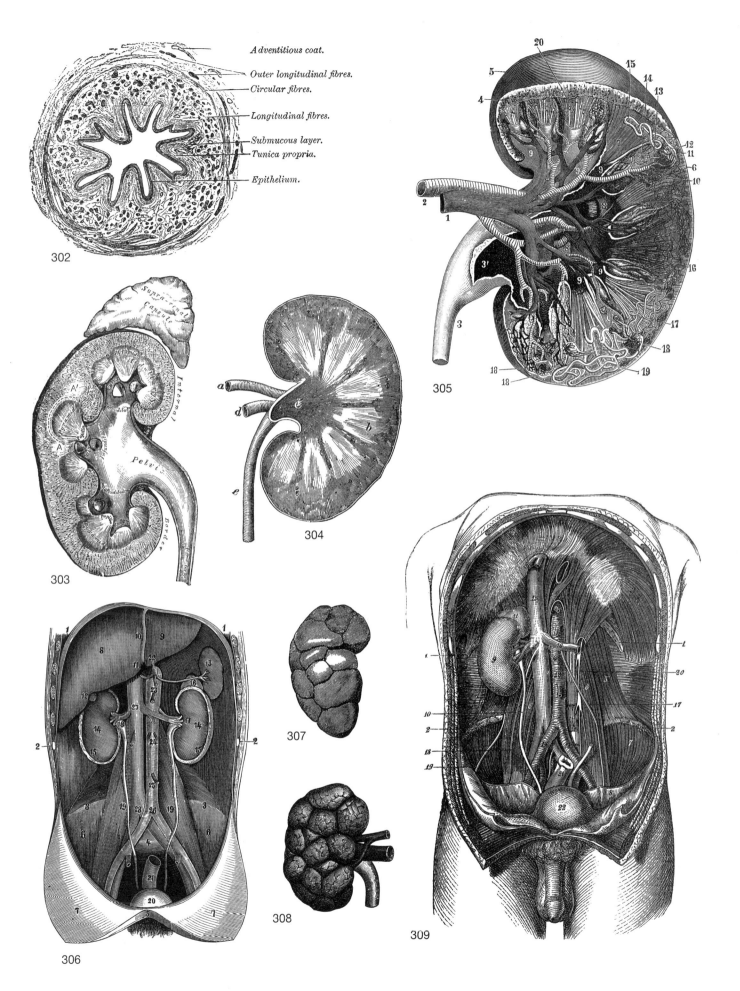

Adventitious coat.

Outer longitudinal fibres.

Circular fibres.

Longitudinal fibres.

Submucous layer.
Tunica propria.

Epithelium.

302

303

304

305

306

307

308

309

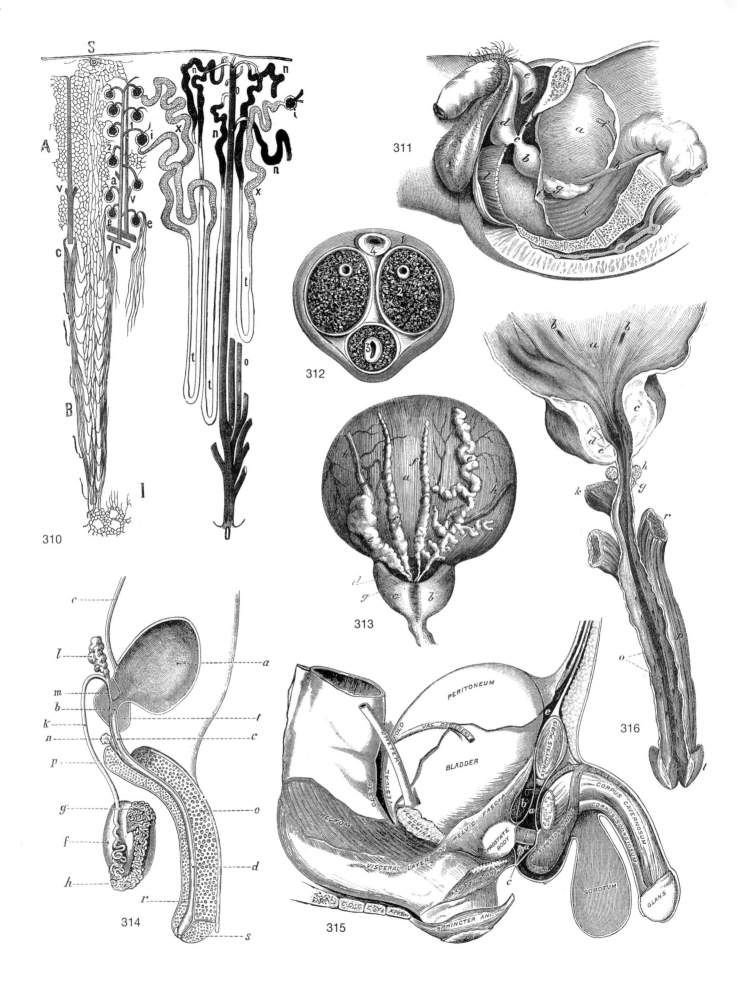

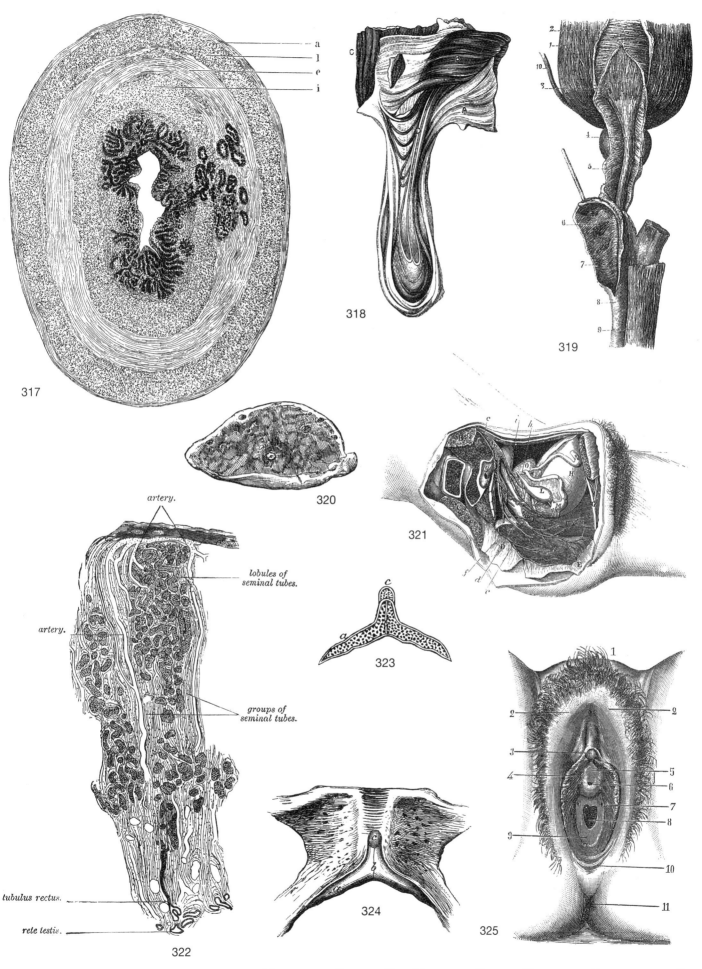

317

318

319

320

artery.

lobules of seminal tubes.

artery.

321

c

a

323

groups of seminal tubes.

tubulus rectus.

rete testis.

322

324

1

2

3

4

9

2

5

6

7

8

10

11

325

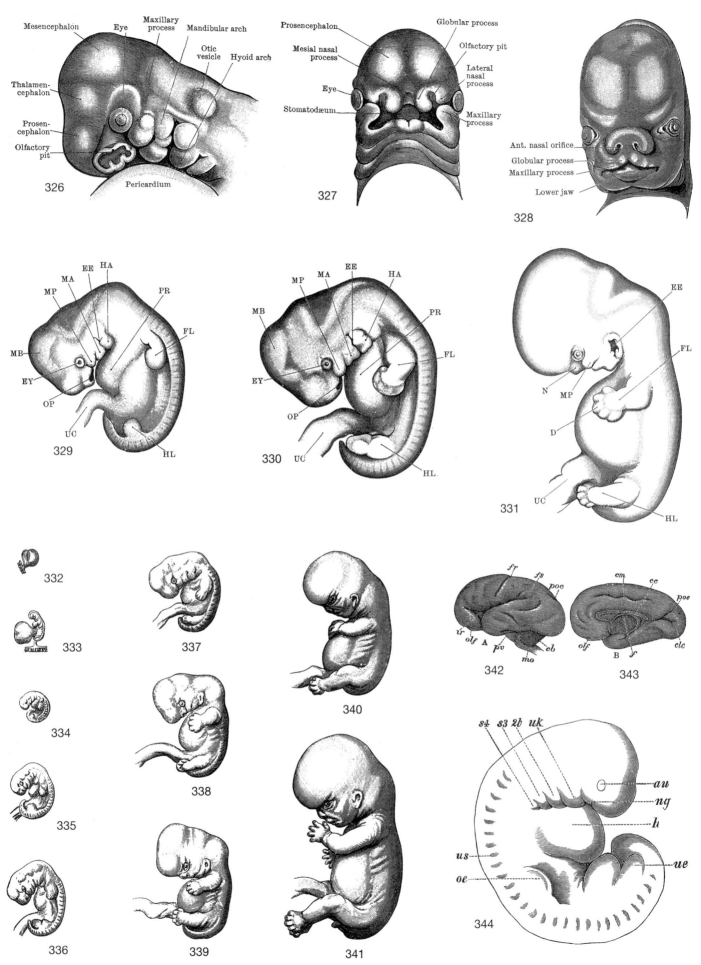

326

Mesencephalon — Eye — Maxillary process — Mandibular arch — Otic vesicle — Hyoid arch — Thalamencephalon — Prosencephalon — Olfactory pit — Pericardium

327

Prosencephalon — Mesial nasal process — Eye — Stomatodæum — Globular process — Olfactory pit — Lateral nasal process — Maxillary process

328

Ant. nasal orifice — Globular process — Maxillary process — Lower jaw

329

MP — MA — EE — HA — PR — MB — EY — OP — UC — HL — FL

330

MB — MP — MA — EE — HA — PR — FL — EY — OP — UC — HL

331

EE — FL — N — MP — D — UC — HL

332

333

334

335

336

337

338

339

340

341

342

ff — fs — poc — ir — olf — A — pv — mo — cb

343

cm — cc — poc — olf — B — f — clc

344

s4 — s3 — 2b — uk — au — ng — h — us — oe — ue

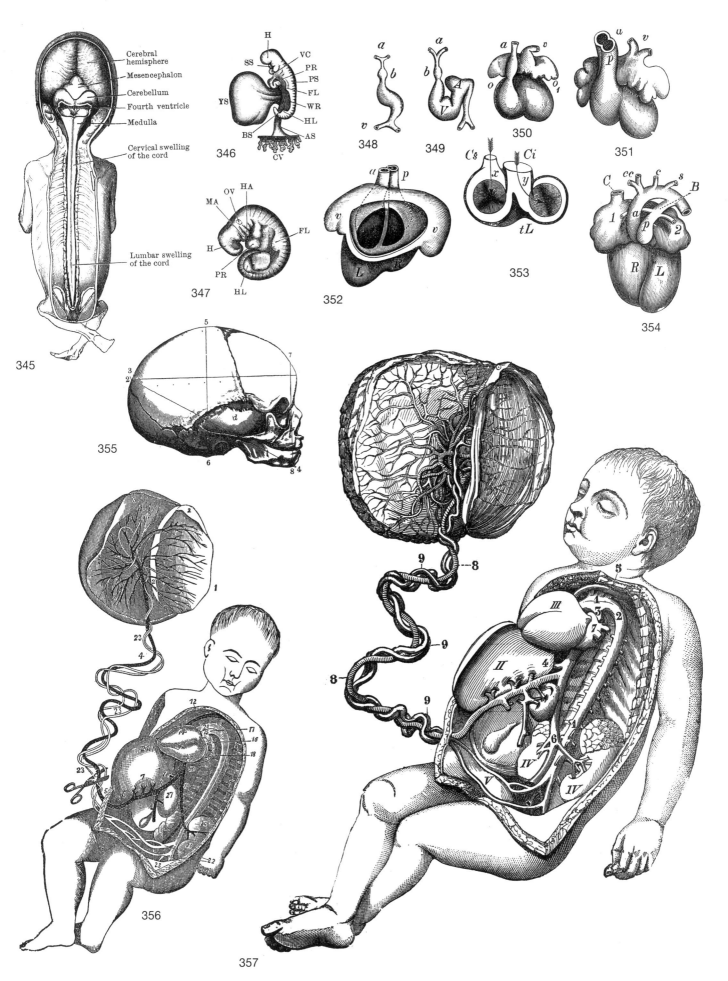

Cerebral
hemisphere

Mesencephalon

Cerebellum

Fourth ventricle

Medulla

Cervical swelling
of the cord

Lumbar swelling
of the cord

345

346

347

348

349

350

351

352

353

354

355

356

357

INDEX